IMAGES
of America

MUSKEGON

IMAGES
of America

MUSKEGON

Norma Lewis and Christine Nyholm

ARCADIA
PUBLISHING

Published by Arcadia Publishing
Charleston, South Carolina

Printed in the United States of America

Library of Congress Control Number: 2018930155

For all general information, please contact Arcadia Publishing:
Telephone 843-853-2070
Fax 843-853-0044
E-mail sales@arcadiapublishing.com
For customer service and orders:
Toll-Free 1-888-313-2665

Visit us on the Internet at www.arcadiapublishing.com

For the De Vries family I married in 2003 and still cherish

—Norma Lewis

In memory of my beloved parents, Norman and Lydia Bude

—Christine Nyholm

CONTENTS

ACKNOWLEDGMENTS

Our first thank-you rightly goes to the Hackley Library in Muskegon. We deeply appreciate the treasure trove of information found in the Local History & Genealogy Department located in the Torrent House. Best of all, the collection is easy to navigate. And for assisting in that navigation, we are grateful to the knowledge and generosity of the staff, especially Jean Town and Daniel Rostar.

We are also indebted to Jeff Bessinger at the Lakeshore Museum Center, the Muskegon County Museum, Heritage Hall at the Calvin College Library, the Bentley Historic Library at the University of Michigan, the Library of Congress, the National Archives, MLive, the *Muskegon Chronicle*, the Grand Rapids Public Library, the Muskegon Lakeshore Chamber of Commerce, the Actors' Colony website, and the Muskegon Heritage Museum.

We are fortunate to work with the talented people at Arcadia Publishing who are dedicated to making the books they do the very best they can be. This includes our title manager, Angel Hisnanick; David Mandel, director of production; Dotti Campbell in sales; and Leigh Scott in appreciation for granting a special request.

We are grateful to Norma's granddaughter Shelby Ayers, who once again rose to the occasion whenever technical help was needed. Last but never least, thanks to our families and friends for their ongoing encouragement.

Unless otherwise noted, all images appear courtesy of the Hackley Public Library, Muskegon, or are in the public domain.

INTRODUCTION

Muskegon's rich and varied history is obvious upon visiting downtown. The historic district proves beyond a doubt that those planners had the wisdom and the foresight to recognize the value of preserving numerous prime architectural examples instead of razing them. Another indication that history is alive and thriving can be found by driving around and reading names on signs. The Hackley Library, Hackley Park, and Hackley Street are just a few of examples of Charles H. Hackley's dedication to, and influence on, his adopted hometown. Though they now have other names, there was also Hackley School, Hackley Hospital, and the Hackley Art Museum. He was not alone in leaving an indelible mark. Others prominent names include Hume, Peck, and Walker, among others.

Lumber first defined the city, followed by shipping and manufacturing. Tourism has always fueled the local economy, as miles of Lake Michigan and Muskegon Lake frontage made it a popular destination from the early days of the plush resorts to today's rental cottages and condominiums. There was, and is, something for everyone. The affluent have always come in their boats or stayed in luxury hotels, while other families enjoyed camping in private campgrounds or state parks. Motels have always provided an affordable option for enjoying the lakes and river making up this slice of heaven on earth.

Denuding of the state's forests ended the lumber industry. The port, the deepest in western Michigan, made shipping an obvious choice for the second Muskegon boom. For a time, it was the mode of choice for transporting goods. Heavy industry came next, with names like Brunswick, Norge, Sealed Power, Shaw-Walker, Misco, and many others offering job security to all who were willing to do the work. Unlike now, people in those days often retired from the same company that gave them their first job.

From a humble beginning of a trading post or two in the early 1800s, Muskegon County had a thriving population of fewer than 4,000 in 1860. By 2017, that number had grown to nearly 40,000 in the city and more than 175,000 counting the rest of the county. Muskegon officially became a village in 1861, with Lyman Davis serving as village president. Eight years later, residents voted to incorporate as a city.

As in any frontier town, with the women came the needed amenities. Some of the churches founded in the late 1800s are still going strong today. Quality education, all the way from preschool through college, has long been a source of local pride. Hospitals were built to treat the sick, and firefighters and policemen kept the city safe. Streetcars provided transportation and served the city well, with the exception of the famous 1919 riot spurred by a fare increase of one penny. The library flourished, and so did parks. Museums opened, and all manner of social services, including the Red Cross, served those in need.

The performing arts have always played a large part in the lives of the residents, and they enjoyed attending the opera. The Michigan Theater, now called the Frauenthal, was where Joe and Myra Keaton, along with their son Buster, delighted audiences with vaudevillian shows.

The Keatons were part of the famed Actors' Colony, and Buster was still a child when he began honing his theatrical skills for an illustrious career in silent films. Max Gruber, another of the more well-known members of the Actors' Colony, performed with his Oddities of the Jungle costars: an elephant who rode a tricycle, a zebra, and a Great Dane.

Muskegon has its share of "hometown boys and girls who made good." Among them are sports legends including Earl Morrall, Ruvell Martin, Bobby Grich, Nate McLouth, and Justin Abdelkader. Two Miss Americas made the county proud. Entertainers include Harry Morgan, Bettye LaVette, and Iggy Pop. Astronaut David Leetsma also once called Muskegon home.

One

THE EARLY YEARS

It was the Ottawa people who actually named the new settlement. Their word *Masquigon*, first used to describe the Muskegon River, translated to "marshy river." French Canadian fur traders appeared on the scene in the first decade of the 19th century and exchanged pelts for cloth, weapons, and other everyday supplies. But lumbering is what defined Muskegon, to the point the city earned the hyperbolic title "Lumber Queen of the World." Fortunes were made as millionaires sprouted like spring daffodils. Some of the mansions in which they lived still remain and give a glimpse into how life was during those glory days. Men on the lower rungs of the social ladder prospered, too, as jobs were plentiful and hard workers always in demand. In 1850, the settlement boasted six sawmills. By 1875, the number had grown to 47.

The lumber industry peaked in the late 1880s when overzealous lumbermen had denuded the forests from which they earned their fortunes. Muskegon lumber not only built Muskegon, but Chicago as well. The Great Chicago Fire of 1871 destroyed more than three square miles and left 100,000 homeless. About 20 years later, Muskegon's famous Pine Street Fire destroyed 17 city blocks and 250 buildings. Those and other fires suggested that lumber might not be the best building material after all. Some of the newly minted millionaires took the money and ran. Others, men of vision, stayed on, determined to make the area all that it could be.

If Muskegon was to survive, the time had come to reinvent itself. The men who remained had created one economic boom and were confident they could do it again.

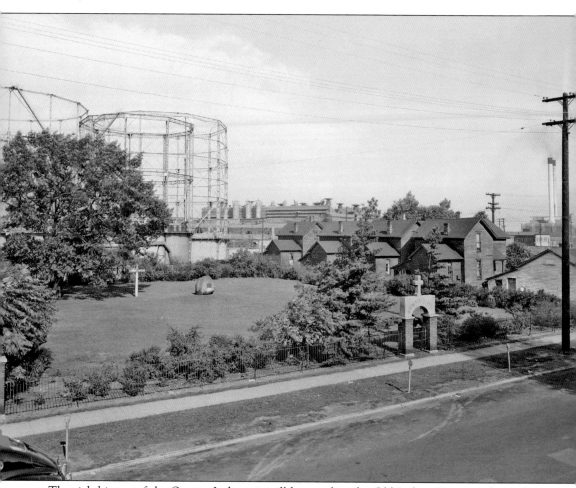

The rich history of the Ottawa Indians is still honored in the Old Indian Cemetery located at 298 Morris Avenue. Lumber baron and the city's first millionaire, Martin Ryerson, deeded an acre of land to the city for the original Ottawa Nation burying ground and stipulated that it be maintained in perpetuity.

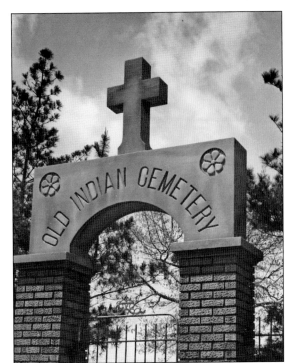

Details from later improvements show the elaborate gate (right) and the marker on the large rock (below). The cemetery is believed to have been used as early as 1750, and in the first half of the 19th century both the Ottawa and early Muskegon pioneers were buried there.

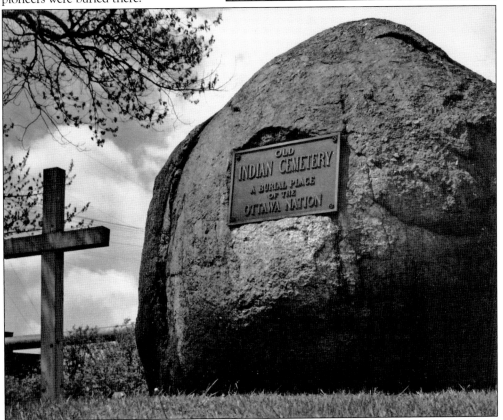

JEAN BAPTISTE RECOLLECT TRADING POST

Near this site, on the shore of Muskegon Lake, stood the first Indian fur trading post in Muskegon County. It was established in 1812 by Jean Baptiste Recollect, a French fur trader believed to be this area's first white settler. Jean Recollect remained here for about a year when a new manager took over. The Muskegon post operated as a successful business enterprise for many years. Remains of the chimney of Recollect's station were visible as late as 1836.

MICHIGAN HISTORY DIVISION, DEPARTMENT OF STATE
REGISTERED LOCAL SITE NO. 726
PROPERTY OF THE STATE OF MICHIGAN, 1980

This historical marker sits near the site of the first fur trading post in the Muskegon area.

The second permanent settler was Joseph Troutier, who was known as Truckee and operated Truckee's Maple Island Trading Post, pictured above. While Truckee's bookkeeping methods probably would not pass muster with an auditor today, it served the proprietor well in the early 1800s. Martin Ryerson's first Muskegon job was working as a cook for Truckee.

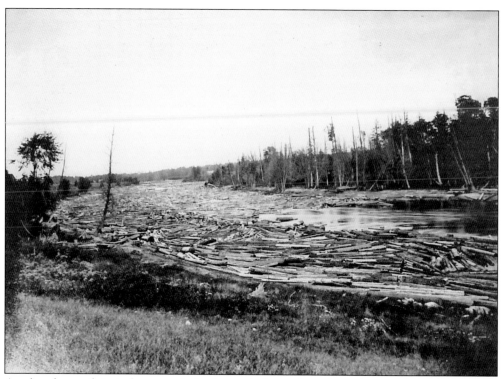

An abundance of virgin forests made lumber an industry throughout the state, but nowhere more than Muskegon. The Muskegon River (above) became a river of logs in 1887 when it was said a person could walk miles on the river and never get his shoes wet. The city's Lake Michigan frontage made it the logical spot for sawmills by providing easy transport to the world beyond. In addition to the river, oxen and rails were pressed into service (below).

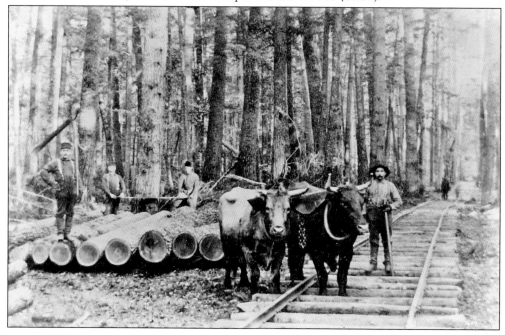

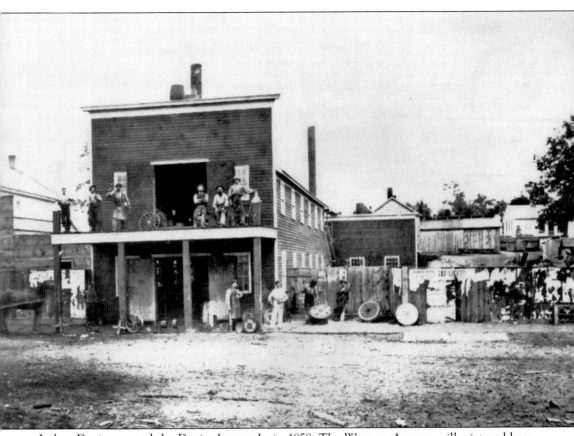

Joshua Davies opened the Davies Ironworks in 1858. The Western Avenue mill, pictured here in 1874, repaired sawmill machinery and produced the products necessary to keep the mills running smoothly.

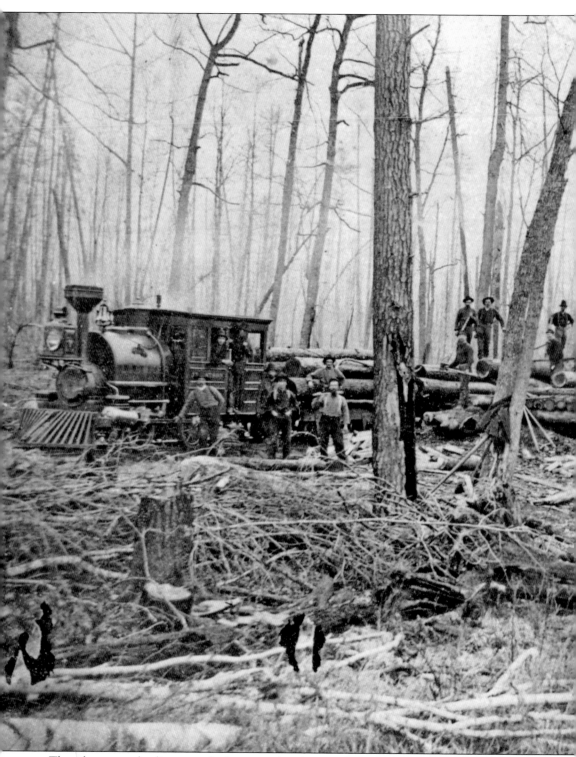

These loggers are loading a standard-gauge railroad train at Lake George and the Muskegon River, a scene that would be replicated countless times and in numerous locations during the state's

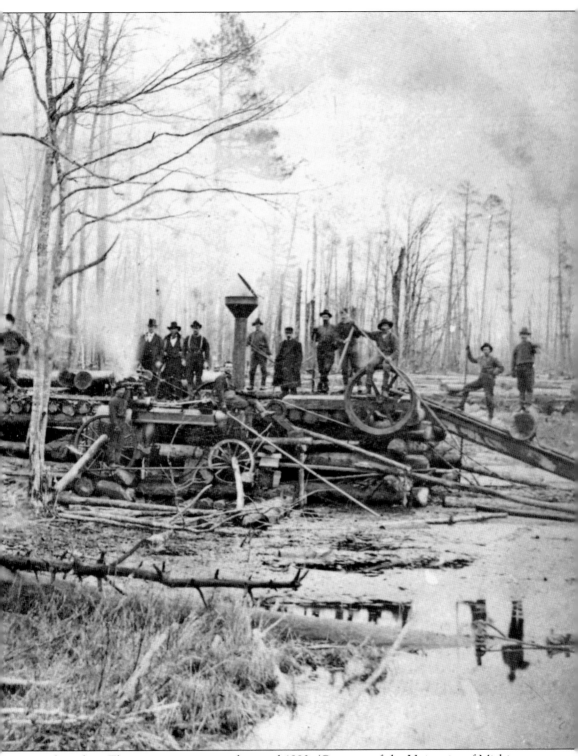

earliest days. This image was captured around 1880. (Courtesy of the University of Michigan, Bentley Historical Library.)

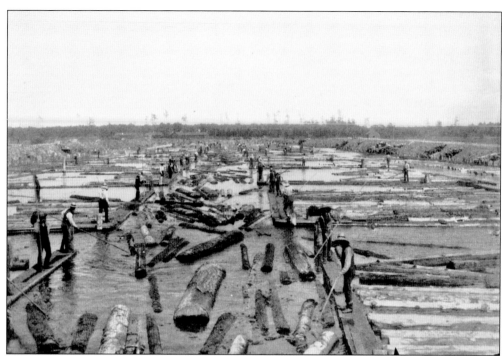

Muskegon Booming Company employees did important work at the sorting grounds (above). All logs bore marks indicating which logs went to which mill. John Torrent was the company's president and also served three times as mayor. His mansion (below) was later used as a mortuary, hospital, and Red Cross headquarters. The city bought the house in 1972, and it now houses the Hackley Library's local history and genealogy archives. The Red Cross is now located next door.

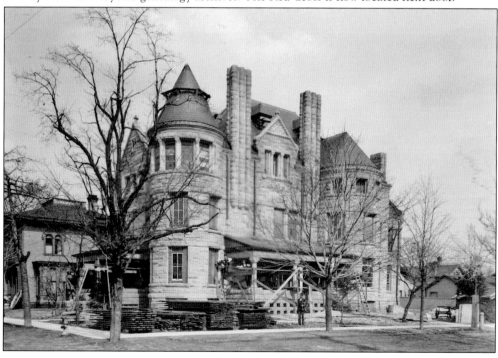

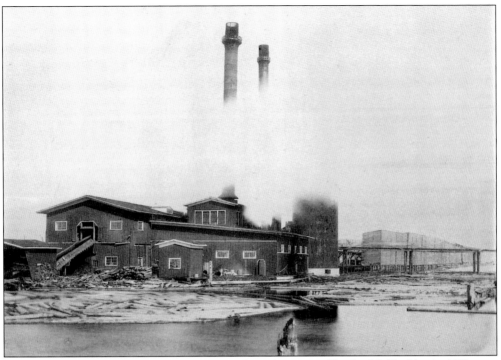

One of the largest lumbering operations was that of partners Charles H. Hackley and Thomas Hume. The exterior of their mill as it looked in 1888 is shown above. Below, pictured from left to right, inside the office located on Western Avenue between Second and Third Streets, are George A. Hume, Thomas Hume, and Charles Hackley.

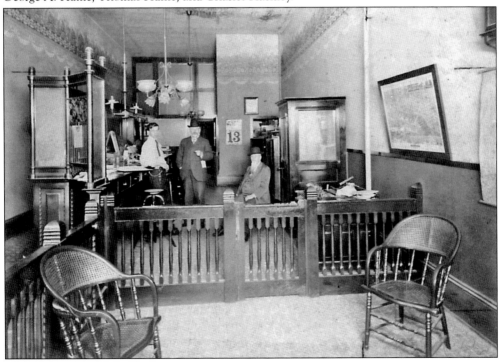

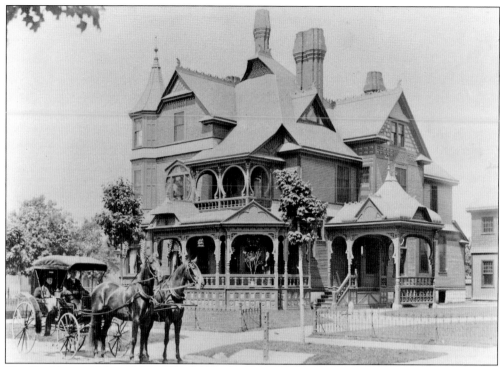

The Hackley and Hume families built their houses next door to each other on Webster Avenue. Still standing, they have been completely restored and are open to the public as the Hackley and Hume Historic Site. The Hackley Victorian home is pictured above, with Julia Hackley on the veranda and Mrs. L.B. Smith in the carriage. The coachman is Taylor Bullis. Charles and Julia had two children. The image below is the Queen Anne–style home of Thomas Hume and his wife, Margaret.

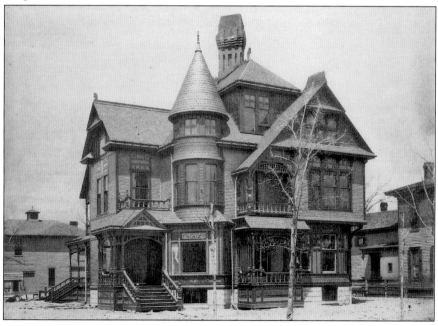

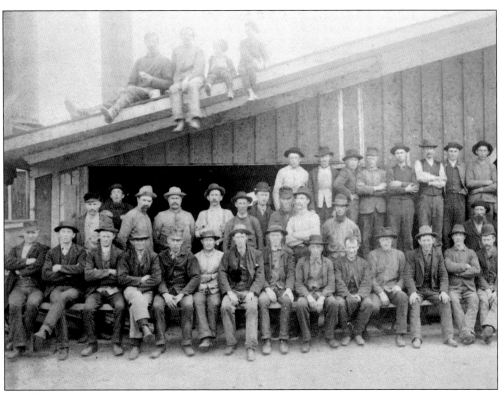

Delos A. Blodgett also became a wealthy lumber baron, and one of his partnerships was with Thomas Byrne. Their mill is pictured here in 1888. He had previously been partners with T.D. Stinson and, later, George Tillotson. Along with lumber, he amassed his fortune as a capitalist in the fields of real estate, banking and insurance, including the Lumberman's National Bank of Muskegon. Blodgett eventually settled permanently in Grand Rapids, where his son established the health-care facility that later became the Blodgett Hospital.

Matthew Wilson, another lumberman, served in the Michigan senate. His home, shown here, was located on Muskegon Avenue between Terrace and Pine Streets. It was destroyed by the Pine Street Fire in 1891, and the property is now the site of the Muskegon County jail.

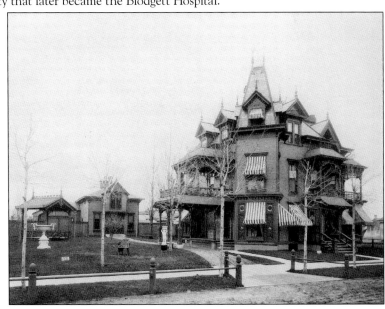

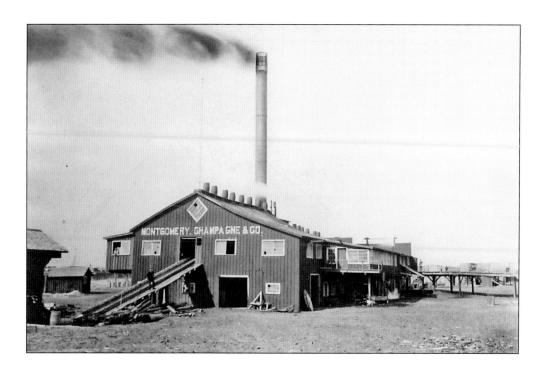

The Montgomery, Champagne & Company Mill operation (above) was located on Ruddiman Creek. Mill workers below pose for a photograph around 1890.

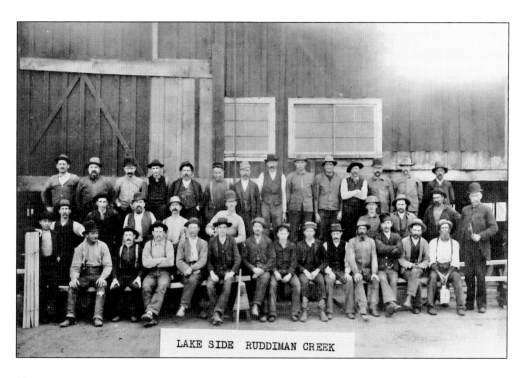

LAKE SIDE RUDDIMAN CREEK

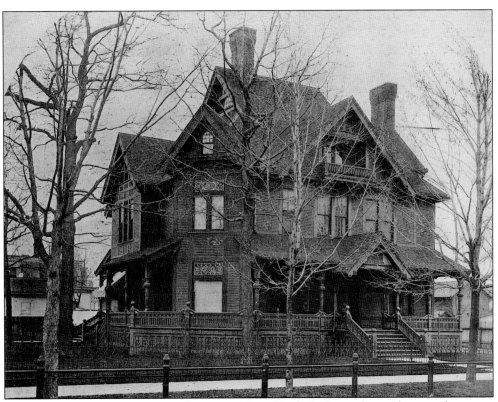

Mill owner C.T. Hills arrived in Muskegon in 1852 and built the house shown above on the corner of Webster Avenue and Fifth Street. Company images of the mill workers seems to have been obligatory, and the Hills crew lined up for the camera in the photograph below.

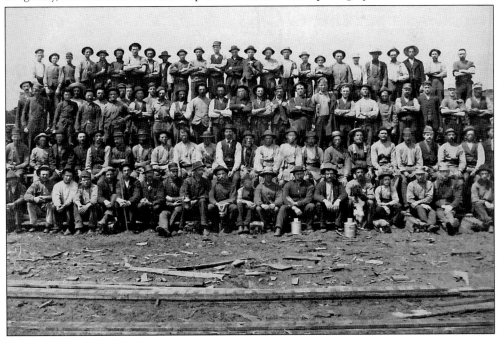

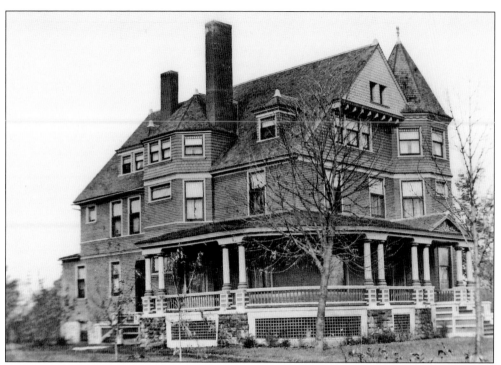

A.S. Montgomery built his family residence at 1691 Jefferson Street. The property was later owned by John Campbell, followed by William E. Jeanot. The map below shows how Muskegon looked in 1868. Lumber was the chief industry and the waterfront shows logs awaiting transport. The map lists 18 sawmills, 6 hotels, 6 churches, Union School, a cemetery, opera house, and Masonic Hall.

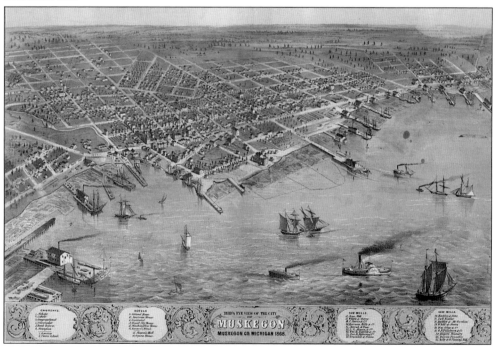

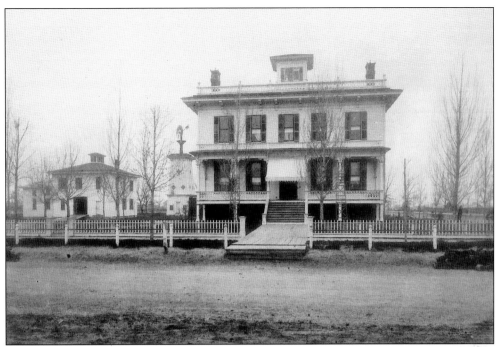

Like most of the lumber barons, Lyman. G. Mason lived in a luxurious mansion, pictured above. Union School sat on his property until he bought it and had the school moved to Jefferson Street. The house he built contained 30 rooms and eight fireplaces. In 1903, the Sisters of Mercy bought the property and turned it into the city's first Mercy Hospital. Below are the mills of the Thayer Lumber Company as they looked in 1888.

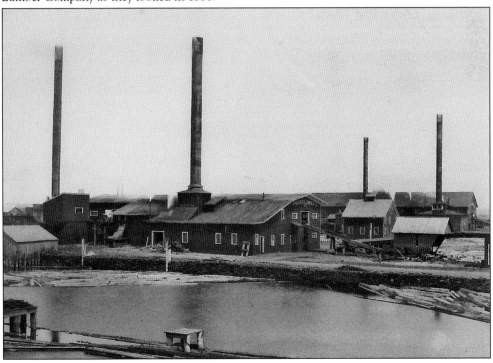

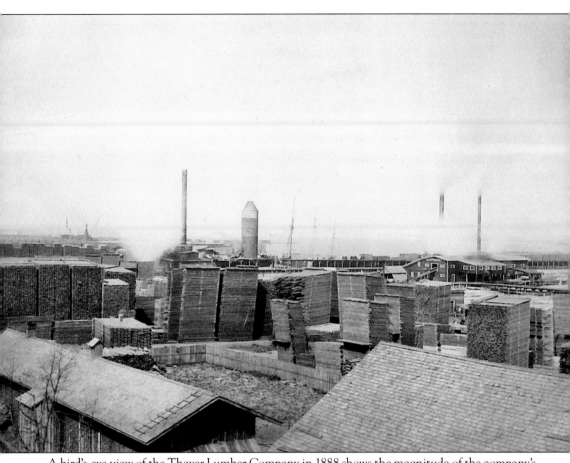

A bird's-eye view of the Thayer Lumber Company in 1888 shows the magnitude of the company's vast empire.

Two

From Lumber Queen to Port City

The Muskegon port has been an integral part of the city that has been nicknamed "Port City," "the Lumber Queen of the World," "the Riviera of the Midwest," and "the Coney Island of the West." The deepest port in Western Michigan, the Muskegon Port could accommodate the largest of ships that traveled the magnificent Great Lakes. Muskegon's port was an important point of entry for transporting goods and people in and out of the region, making it a hub for commerce, industry, and tourism.

The port city is notable for its maritime past and present. The USS *Silversides* submarine rests in the Muskegon Port, where visitors can tour the World War II submarine. The USS *LST 393* and the *Milwaukee Clipper* are also in the harbor, where visitors can learn about their history.

Lumber from Muskegon was transported across Lake Michigan to Chicago, to rebuild the city after the Chicago Fire. Eventually, the forests disappeared, and the sawmills closed. Some of the wealthy lumber barons left. A notable exception was Charles Hackley and his business partner Thomas Hume, who made significant contributions to the arts and the economy of Muskegon.

The Muskegon shoreline was dotted with parks, beach pavilions, amusement rides, restaurants, ice-cream stands, bowling alleys, and more. The area became a mecca for tourists and locals seeking recreation, leisure, sports, and entertainment. Charmed by the beauty of the area, vaudevillians flocked to the Actors' Colony in Bluffton, which was founded by the parents of silent film star Buster Keaton.

Parks and natural areas line the freshwater shorelines of Lake Michigan and Muskegon Lake, so people can enjoy the natural beauty of nature and colorful sunsets. Families visit Muskegon's parks for sports and wholesome playtime, including camping, swimming, boating, water-skiing, and sunbathing.

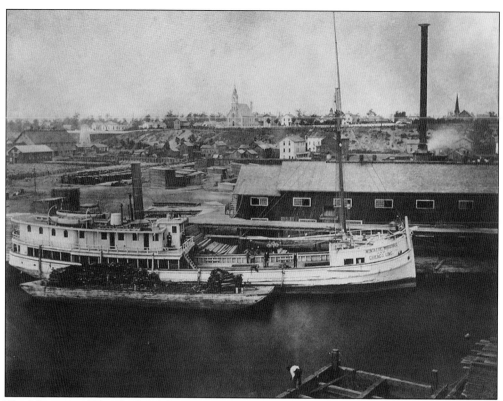

The Montague, Whitehall & Chicago Line hauled lumber on Lake Michigan.

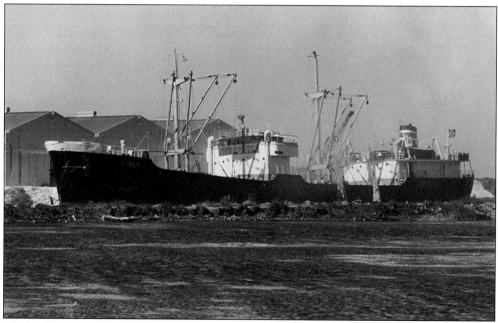

The *Diala* was a charter vessel that crossed the ocean and traversed the Great Lakes to carry English China clay from Fowey, England, to Muskegon and the Kalamazoo Valley for the paper mills.

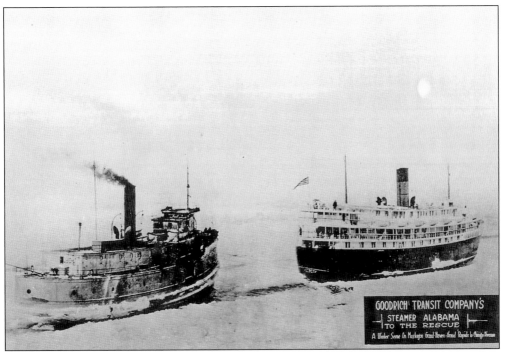

This 1888 photograph shows transportation boats at a pier in Muskegon. The Muskegon port is the deepest port on the west side of Michigan.

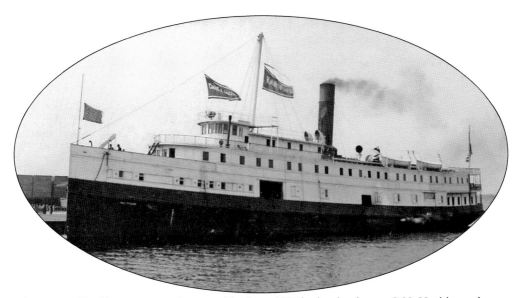

The *Erie L. Hackley* was a wooden vessel built in 1882 by lumber baron C.H. Hackley to honor his daughter. The ship carried passengers and freight around the Muskegon area as part of the North Muskegon Ferry Line. In 1903, the ship was purchased by the Fish Creek Transportation Company to serve its Green Bay route. The ship's final voyage was on October 3, 1903, when it departed from Menominee, Michigan, toward Egg Harbor, Wisconsin, when waves from a storm squall sunk the ship. Only 9 of the 19 people on the ship survived the shipwreck.

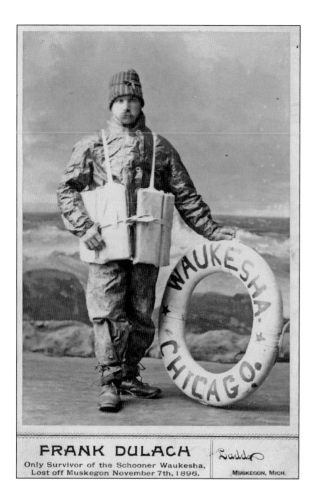

FRANK DULACH
Only Survivor of the Schooner Waukesha,
Lost off Muskegon November 7th, 1896.

Ladd MUSKEGON, MICH.

Frank Dulaca was the only survivor out of a crew of six after the schooner *Waukesha* was hit by a heavy gale of wind and foundered on November 7, 1896. Shipwrecks were a hazard for ships traversing the deep waters of Lake Michigan and on all the Great Lakes. Maritime experts estimate that thousands of shipwrecks are on the bottom of Lake Michigan.

In the foreground is just one of the many ships that used the Lee Ferry Dock. Capt. Seth Lee had an illustrious career as a Great Lakes mariner and businessman.

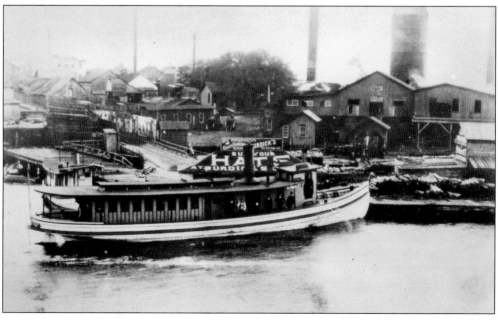

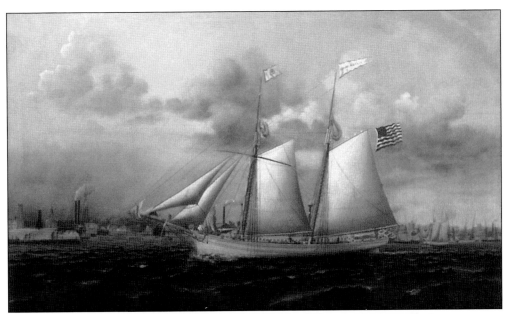

This is a photograph of a painting of the *Lyman M. Davis*. The painting hangs in the permanent collection at the Muskegon Museum of Art, formerly the Hackley Museum. Known as the "fastest schooner on the Great Lakes," the *Lyman M. Davis* carried lumber from Muskegon to Chicago following the Great Chicago Fire of 1871. The wooden schooner was built in Muskegon in 1873 and rode triumphantly through the Great Lakes for more than half a century. Tragically, she was destroyed in 1934, when she was set on fire and sunk off Sunnyside Park in Toronto, to entertain a crowd. (Photograph courtesy of Christine Nyholm collection.)

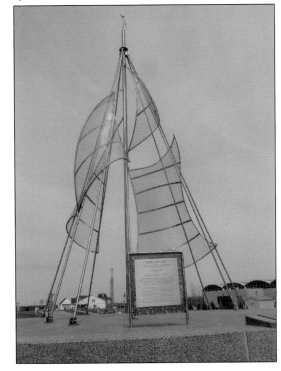

"Sails Ablaze" is an impressive stainless steel and concrete abstract sculpture commemorating Muskegon's famous schooner the *Lyman M. Davis*. The sculpture, which stands on the Terrace Point Traffic Circle, is by sculptor Steve Anderson and is dated 2016. (Photograph by Christine Nyholm.)

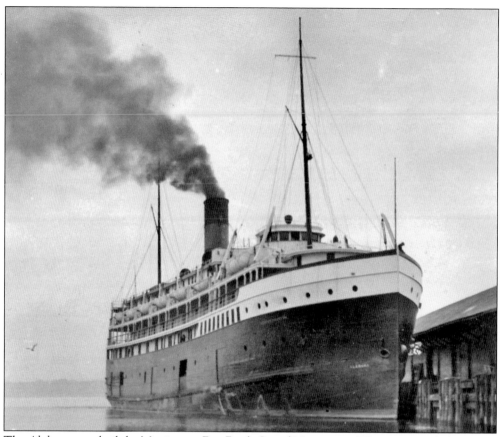

The *Alabama* was built by Manitowoc Dry Dock Co. of Manitowoc, Wisconsin, and christened in 1909 by Elizabeth Goodrich, daughter of Albert W. Goodrich, for the Goodrich Transit Co. of Chicago. The cruise ship was licensed to carry 2,000 passengers with overnight accommodations, and it ran year-round. The proud ship was reclassified as a barge in 1962 and was scrapped in Ontario in 2006.

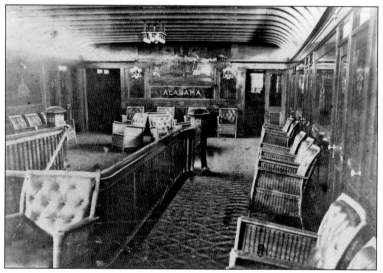

The interior of the *Alabama* shows the seating on which passengers rested while crossing Lake Michigan.

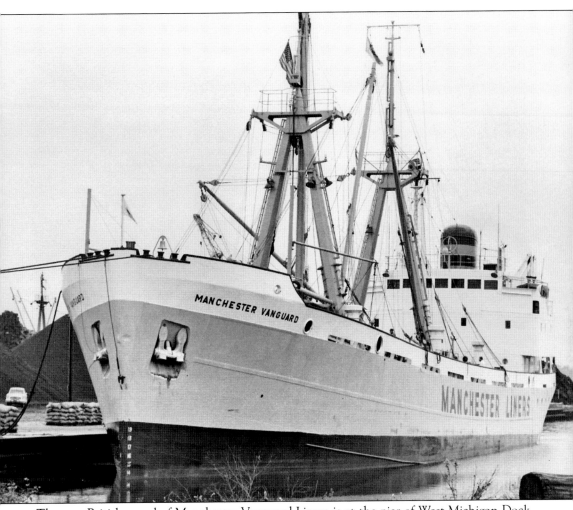

The new British vessel of Manchester Vanguard Liners is at the pier of West Michigan Dock & Market Corporation to load a shipment of pea beans for delivery to the continent. Western Michigan is known for agriculture, and the deep lake port of Muskegon offers a means to ship produce and other products throughout the Great Lakes and across the ocean.

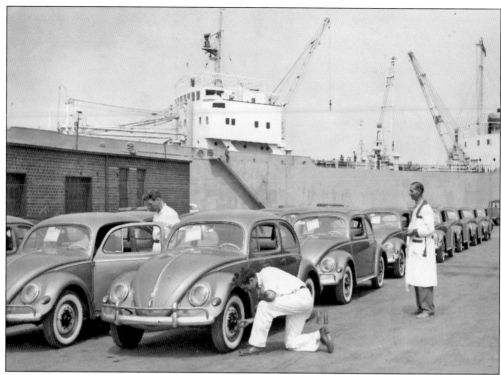

A shipment of German Volkswagen automobiles was photographed as they were delivered at the port in Muskegon.

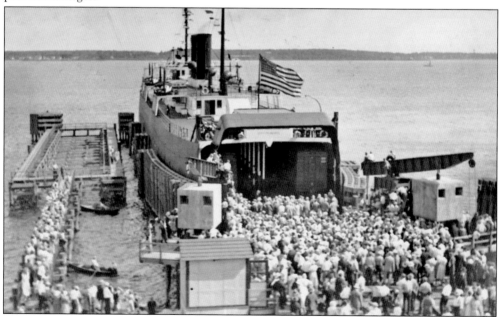

A crowd of people is on the dock by the SS *City of Milwaukee* in Muskegon. The ship transported passengers and cars across Lake Michigan between Milwaukee and Muskegon. The ship, built in 1931, is now a museum and the sole surviving Great Lakes railroad car ferry. The SS *City of Milwaukee* is a National Historic Landmark and is in the National Register of Historic Places.

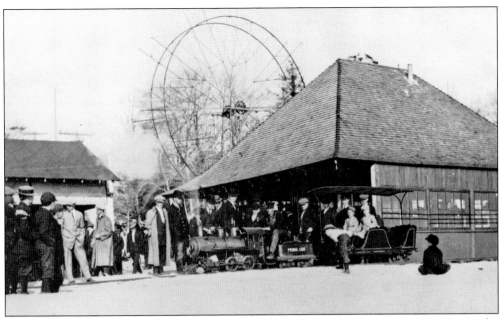

Lake Michigan Park and the beach grew in popularity in the late 1800s and early 1900s. As the area became more popular, structures were built for the convenience of guests. McGowen's, in this 1915 photograph, was located at the entrance to the park. The comfort pavilion offered a lunch counter and picnic area where people could relax and enjoy the atmosphere in this beautiful lakeside setting.

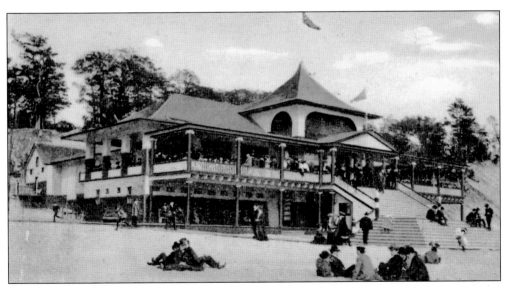

People sitting on the beach in front of the theater at Lake Michigan Park enjoyed a leisurely day sunbathing on the sandy beach in 1907. Muskegon was advertised at "the Coney Island of the West" and "the Riviera of the Midwest." Lake Michigan Park is now known as Pere Marquette Park. (Courtesy of the Norma Lewis collection.)

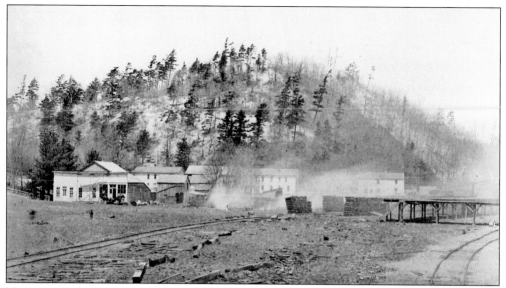

Visitors to Lake Michigan Park could find amusement rides, such as this miniature railroad, for family-oriented fun. The beachfront park was referred to as the Coney Island of the West. Muskegon was promoted as a summer vacation destination in a 1908 publication from the Muskegon Chamber of Commerce, which described the beach and boardwalk as lined with amusements, a roller coaster, restaurants, dance halls, bowling alleys, bandstand, ice-cream parlors, and more.

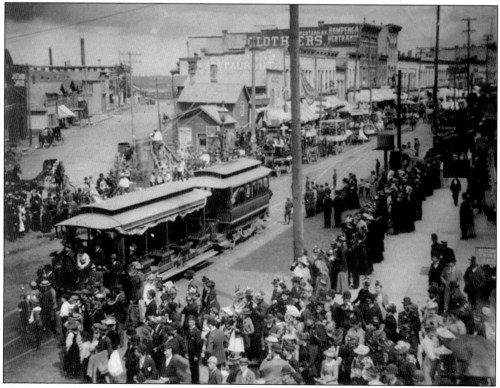

This image of the parade on September 5, 1892, shows a crowd surrounding the trolley cars on Market and Western Streets.

A woman stands on the Boardwalk at Lake Michigan Park, in this photograph from about 1890. There is bluff to the left and a trolley car in the background to the right. The woman could be a resident of Bluffton's Actors' Colony, visiting the area for a beach vacation, or a resident taking a walk in the park now known as Pere Marquette Park.

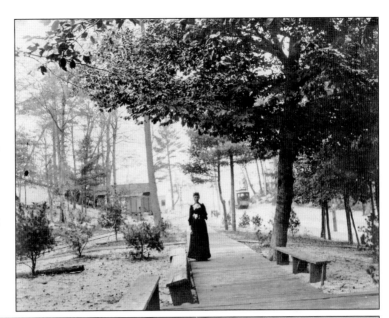

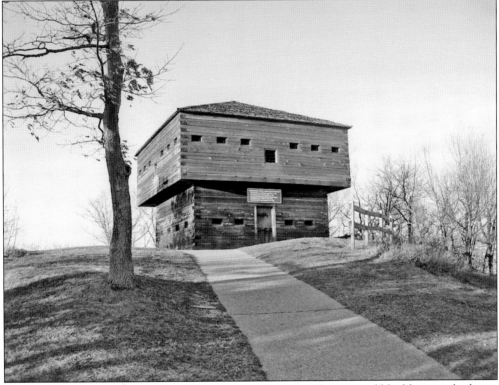

The blockhouse in Muskegon State Park is a reproduction of the original blockhouse, which was destroyed by a gang of young arsonists in 1962. They said it was Tuesday and they were bored. The boys were convicted and required to help rebuild it as part of their probation. The original blockhouse was part of a federally funded make-work program by Pres. Franklin D. Roosevelt's New Deal during the Depression from 1933 to 1942. (Courtesy of the Bentley Historical Library, University of Michigan.)

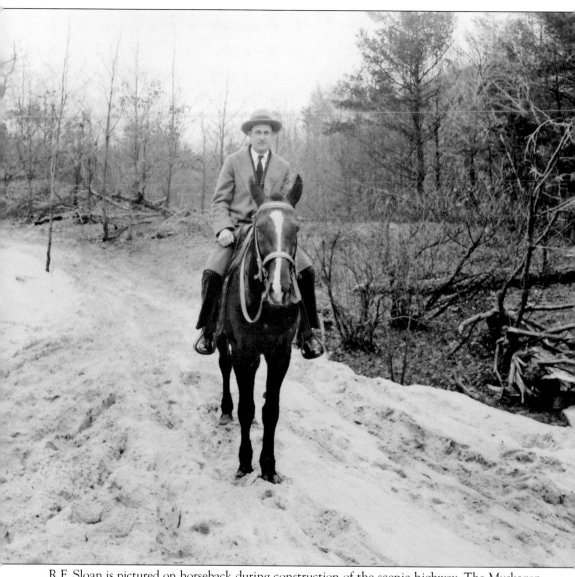

R.F. Sloan is pictured on horseback during construction of the scenic highway. The Muskegon County Road Commission authorized the project, and the Sloan-Lyons Construction Company was chosen to do the work.

Nick Trierweiler is seen here at the caretaker's house at the Muskegon State Park, which has two miles of shoreline on Lake Michigan and one mile of shoreline on Muskegon Lake.

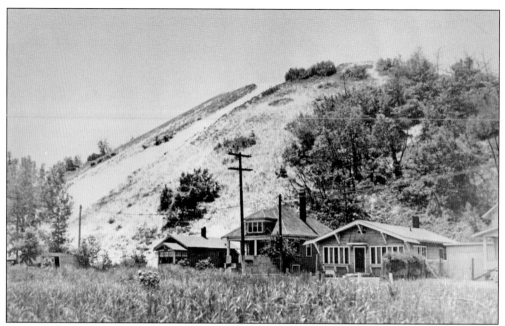

Pigeon Hill was a majestic sand dune that was once located across the street from Lake Michigan Park. The dune was a visible landmark and once the home of thousands of passenger pigeons, which was how it got its name. The sand dune, which was a backdrop to Bluffton and the famous Actors' Colony, was sold, and the sand was mined for industrial purposes and shipped away, so the sand dune no longer exists. Like Pigeon Hill, the passenger pigeon species has been considered extinct since the early 1900s.

Steps on the steep sand dune to the beach and the lakefront were useful walkways for people visiting the beach.

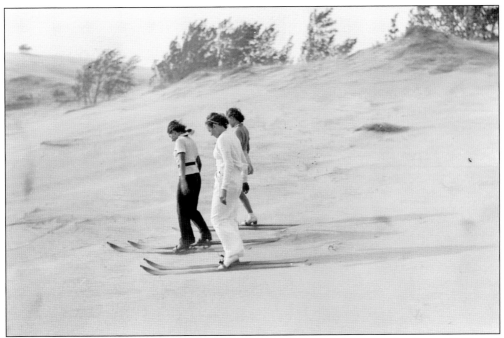

Three women enjoy fresh air and exercise while cross-country skiing on the Pigeon Hill sand dune on the lakefront.

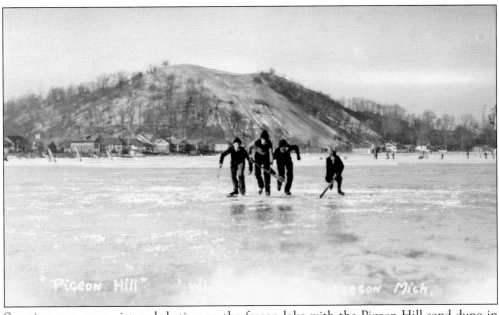

Sporting men were pictured skating on the frozen lake with the Pigeon Hill sand dune in the background.

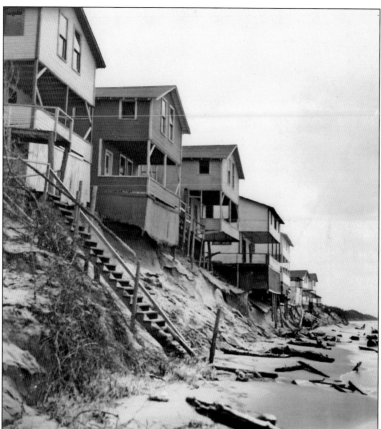

Houses stood above the waterline, threatened by beach erosion, a hazard of beach living that can undermine the foundation of the structures on the beach.

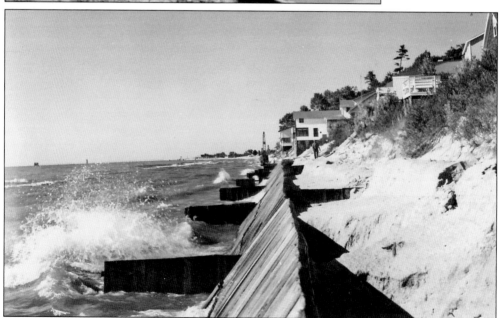

Extensive beach erosion in 1952 led to the removal of some prime lake shore cottages, as not all could be restored.

42

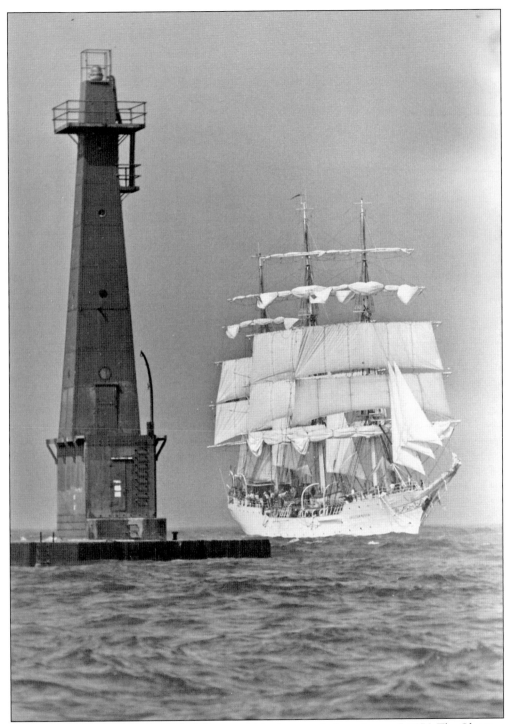

The *Christian Radich* sails past the lighthouse in this photograph from August 5, 1976. The *Christian Radich* is a Norwegian ship that sailed to the United States as part of the bicentennial celebration of the United States. The Muskegon South Pierhead and South Breakwater lighthouses are listed in the National Register of Historic Places.

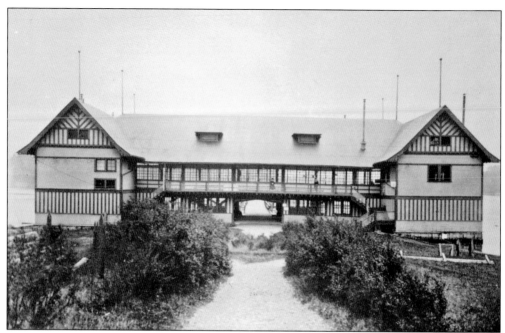

The Pamona Pavilion, located on the north side of Spring Lake, was built in 1902. The pavilion was sold to band leader Frank Lockage in 1928, and he began bringing in nationally known entertainers of the Big Band era, including the Glenn Miller Band, Tommy Dorsey, Jimmy Dorsey, Vaughn Monroe, Lawrence Welk, and Buddy Holly. People came to Fruitport to dance and party to the music. The excitement lasted until 1963, when the pavilion was destroyed by fire. (Courtesy of the Grand Rapids Public Library.)

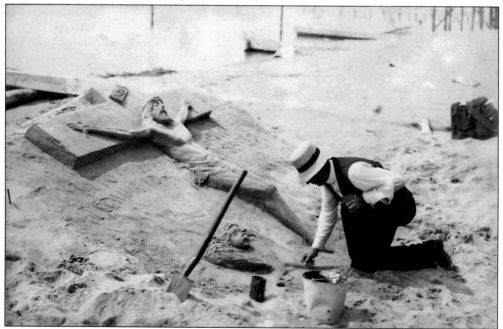

Beach sand has always been a popular medium for sculptors who do not mind the fact that their creative efforts are temporary.

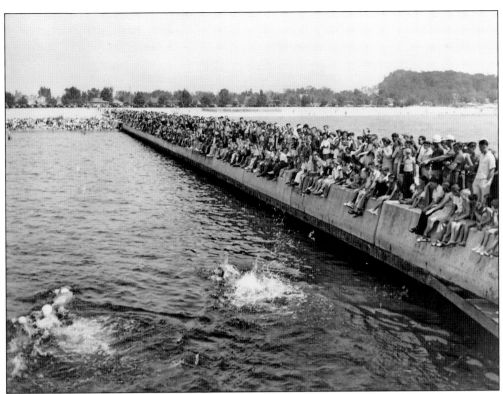

A large crowd on the pier at Pere Marquette Park is gathered to watch swimmers in the lake. Water sports, such as swimming and boating, are popular leisure activities in Muskegon.

People walk along the boardwalk as powerboats speed through the water. Boating continues to be a popular activity on Lake Michigan, Muskegon Lake, and on the other waterways in the area.

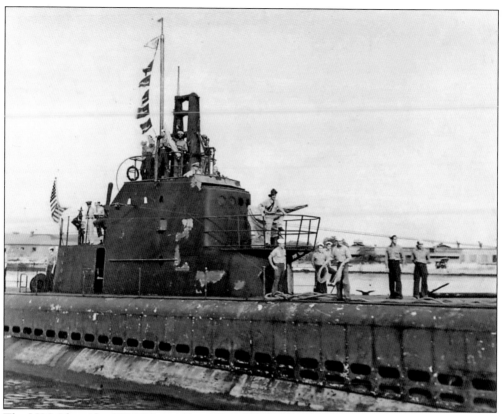

The USS *Silversides* (SS-236) is a Gato-Class World War II submarine that received 11 battle stars for World War II service and one Presidential Unit Citation for cumulative action over four patrols. The submarine had a prolific wartime combat record and is credited with sinking 23 ships. USS *Silversides* was filmed for exterior scenes in the movie *Below,* which depicted the fictional submarine USS *Tiger Shark.*

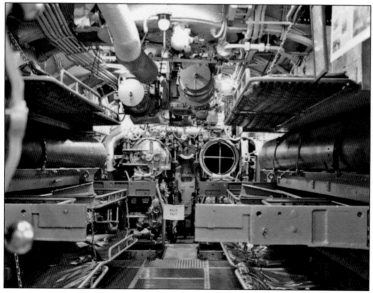

The interior of the USS *Silversides* is pictured here. The submarine has been retired, was restored by volunteers, and is now the centerpiece of the Silverside Museum in Muskegon, serving to educate the public about wartime.

The US Coast Guard Rescue Station was established on the north side of the channel in 1890 and relocated to the south side in 1915, where it still stands. The fifth branch of the country's military service, the Coast Guard is charged with preventing smuggling and conducting rescue missions, among other duties. Muskegon's station does this with 22 active and 5 reserve men and women.

Montague displays the world's largest weather vane topped by a sculpture of lumber schooner *Ella Ellenwood*. The ship sank in Lake Michigan, off the shore of Milwaukee in 1901. When her nameplate miraculously floated back 60 miles to her home port of White Lake, people proclaimed that she had come back home. (Photograph by Christine Nyholm)

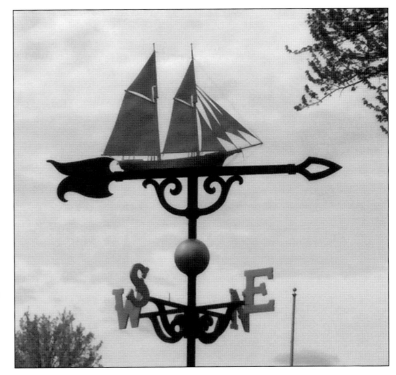

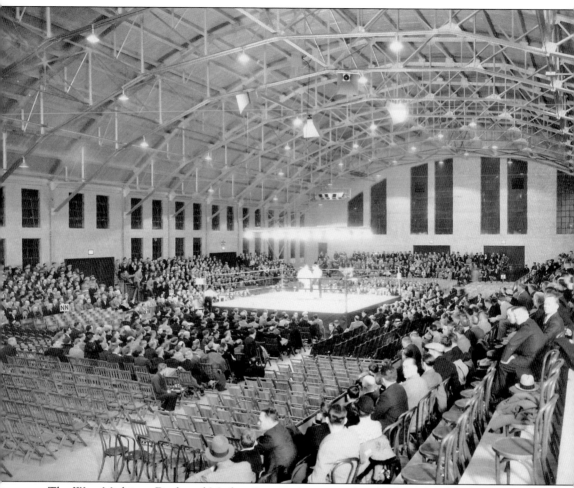

The West Michigan Dock and Market Corporation opened in 1933 on the old Thayer Lumber Company site. It had retail and storage space along with an auditorium to host athletic events like the boxing match shown here.

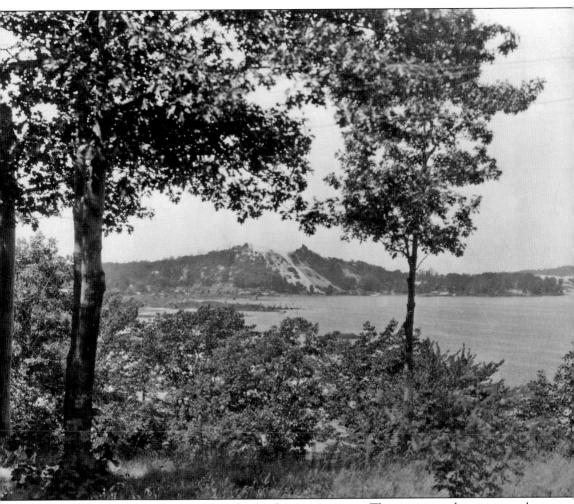

Pigeon Hill provides a scenic backdrop for the shimmering water. The pigeons are long gone, and so is the hill. Passenger pigeons are extinct, and the hill provided sand for expansion projects.

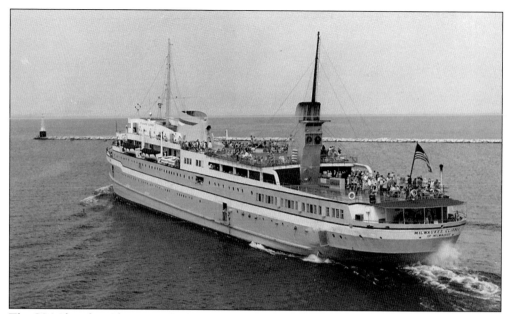

The SS *Milwaukee Clipper* was built in 1905 and substantially rebuilt in 1940. The vessel is the oldest Great Lakes passenger steamship in the United States and possesses national historical significance. The steamship was designated a National Landmark in 1989 by the National Park Service and the United States Department of the Interior.

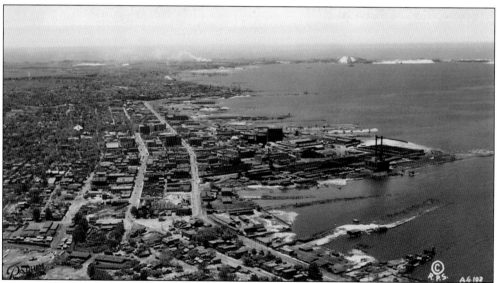

This aerial view of the Muskegon Harbor in 1930 shows the burgeoning industry in the city.

Three

COMMERCE AND INDUSTRY

The shipping industry had long filled the gap left by the logging and lumbering that preceded it. Then it also vanished, mostly because of the city's failure to modernize. Following that was a period of steady industrial growth with companies like Chase Piano, Continental, Sealed Power, Brunswick, and Shaw-Walker, among the larger. Once again, good-paying jobs were there for the taking. Unlike today, loyalty was alive and well among both employees and management. Some people spent their entire working years with one company, and it was not unusual for several family members to work at the same company, often representing two or more generations.

That all changed during the last decades of the 1900s, when not only Muskegon but the entire Midwest became known as the Rustbelt. Factories closed, some permanently, and others were lured away. Worse, Ross Perot was right when he famously talked about that "giant sucking sound" during the 1992 presidential debates that was the sound of viewers' jobs fleeing the country.

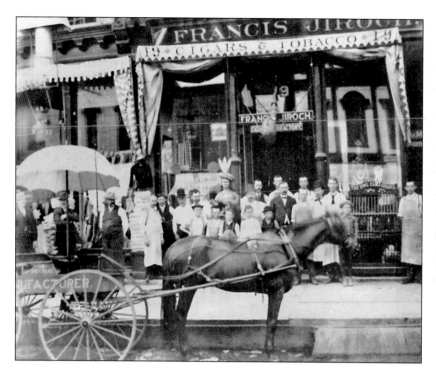

In this c. 1890 photograph, a horse-drawn delivery wagon is in front of the Francis Jiroch cigar shop at 19 West Western Avenue in Muskegon. Jiroch was a cigar manufacturer and tobacco dealer.

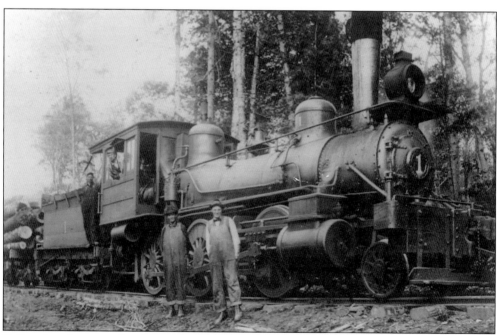

Railroad workers stand in front of a steam engine in this photograph. The railroad boom hit Muskegon in 1869 when W.S. Gerrish introduced the narrow-gauge railroad to serve the vital logging industry. It was a major improvement over previous lumber transportation. In 1938, Muskegon was served by three national rail lines, employing over 200 men. The only rail line still in operation is the Michigan Shore Railroad.

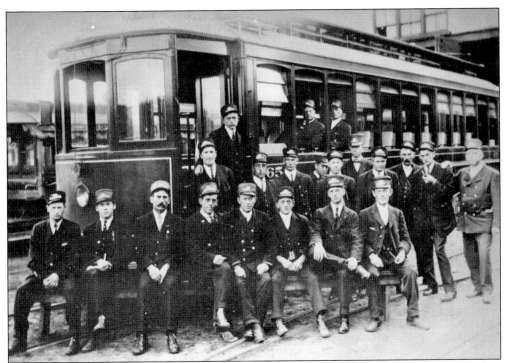

Muskegon Traction, owned by Muskegon Traction and Lighting Company, was the city's trolley service for 47 years before closing in 1929. There was a riot over a fare increase in 1919, when the fare was raised by a penny from 6¢ to 7¢. This was a significant amount of money during this era, especially to workers who commuted to work several times a week. Patrons of Muskegon Traction were so angered that they overturned the trolley cars, destroying at least 16 cars, as well as damaging other property.

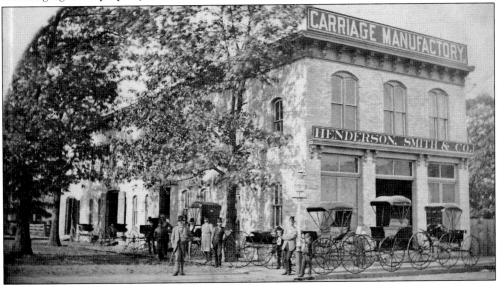

Fine carriages are lined up in front of the Henderson, Smith & Co. Carriage Manufactory. Carriage manufacturers had to be craftsmen proficient in woodworking, painting, trimming, and blacksmithing to produce a well-constructed carriage for transportation.

The Amazon Knitting Building was the home of Amazon Hosiery in 1896 and Amazon Knitting Co., whose president was lumber baron Charles H. Hackley, in 1899. The company closed in 1943, due to changing tastes in hosiery and the other knitted products produced by the employees. The historic downtown building was eventually converted into residential apartments.

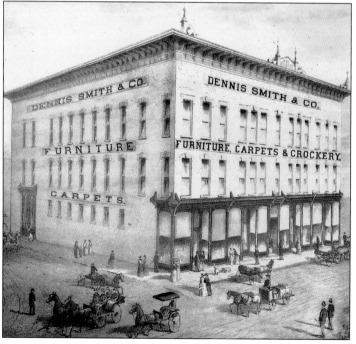

The Dennis Smith & Co. Department store stood on the corner of Terrace and Clay Streets in this photograph from 1888. The store advertises furniture and carpets on the outside of the building. Horse-drawn carriages with passengers and pedestrians are on the street in front of the store in this bustling scene of downtown Muskegon.

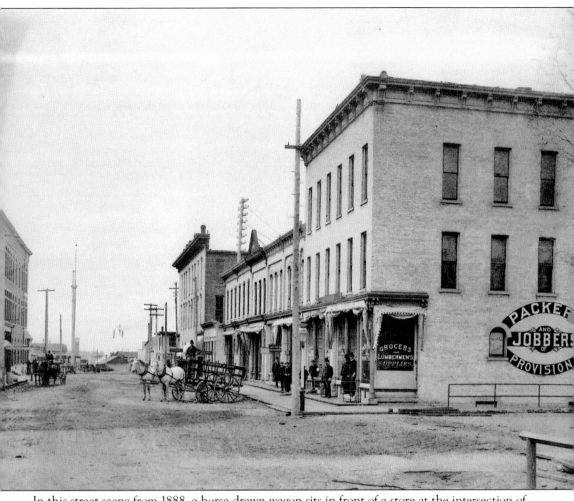

In this street scene from 1888, a horse-drawn wagon sits in front of a store at the intersection of First Street and Clay Avenue. Horse-drawn wagons were an important form of transportation, hauling passengers and supplies around town and across the country before modern means of transportation were invented.

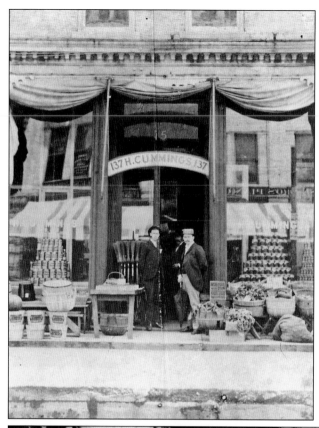

Grocer Henry Cummings (right) and an unidentified man are seen in front of the H. Cummings store, which was located at 75 Western Avenue, opposite the Lyman Block. The photograph, taken in about 1893, shows the grocer and some of the store's produce and products on the boardwalk.

Five men were photographed standing in front of Miller's Hardware Store in 1893. The store was located on the south side of Western Avenue between Terrace and Pine Streets. The men were pictured along with some of the store's products, which were displayed on the boardwalk.

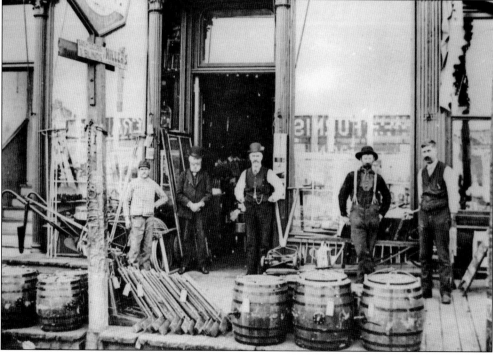

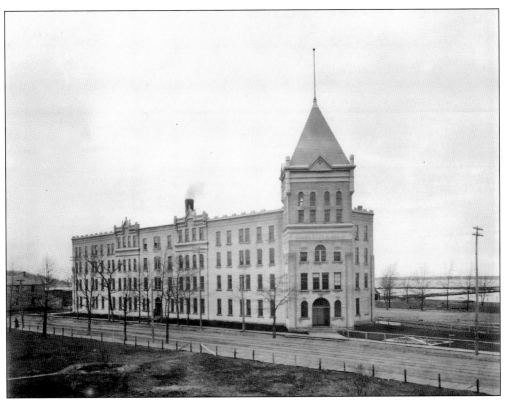

The Chase-Hackley Piano Company opened in 1890, as part of an effort to revitalize Muskegon as the lumber industry waned. The historic building was demolished, along with the Sappi Paper Company, in 2017.

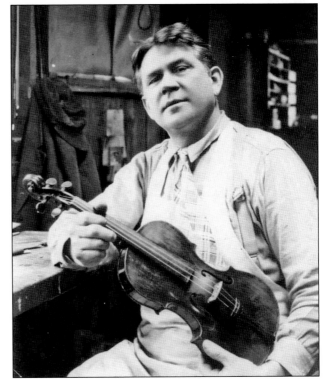

Byron Beebe holds a violin in his shop in Muskegon. Beebe Violins were made by Byron Beebe and his son Emmett from 1909 to 1938. The two men crafted fine violins inspired by the classic Italian instruments, like Stradivarius. The Beebe Violins are considered masterpieces by professional musicians. (Courtesy of Randolph Beebe/Beebe Violins.)

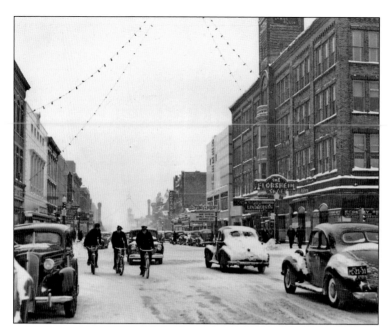

Western Union Telegraph Boys were photographed riding their bikes through winter traffic to deliver telegrams. The photograph was taken looking west from First Avenue.

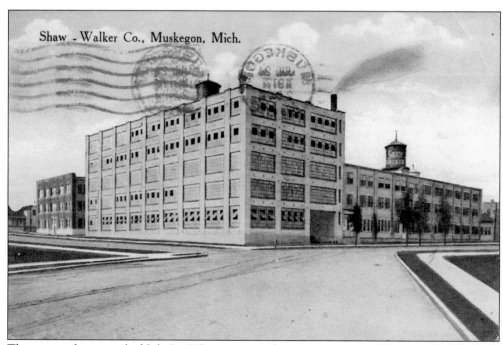

Shaw - Walker Co., Muskegon, Mich.

This postcard, postmarked July 2, 1917, was written by a woman named Mabel to the folks back home during her visit to Muskegon: "John still works here in production. Little Johnny just got hired to do bookkeeping of some sort. Ralph wants to work here too but John told him he has to finish school first."

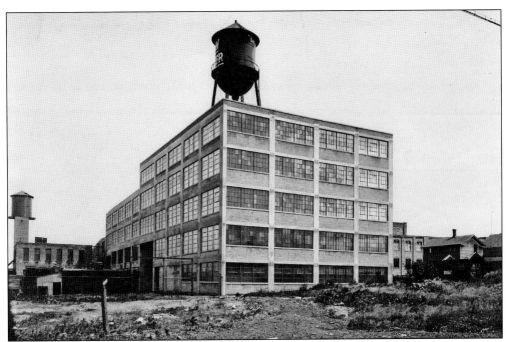

The Shaw-Walker Company Furniture Factory was founded in about 1899 by A.W. Shaw and L.C. Walker. The company produced office furniture, including wooden cabinets to house file cards, steel filing cabinets, and low desks built for the comfort of the office worker. The building is now the Watermark Center. Part of the building of Watermark's mixed-use development has been converted into residential lofts.

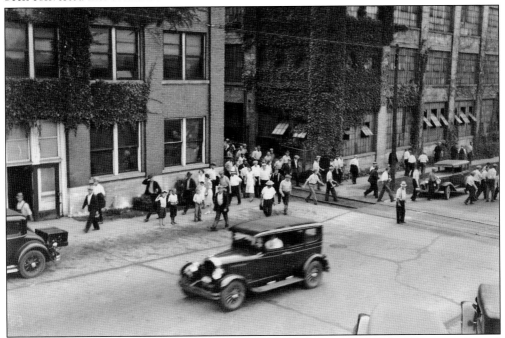

People are seen leaving Shaw-Walker Company, probably leaving work to head home at the end of their workday.

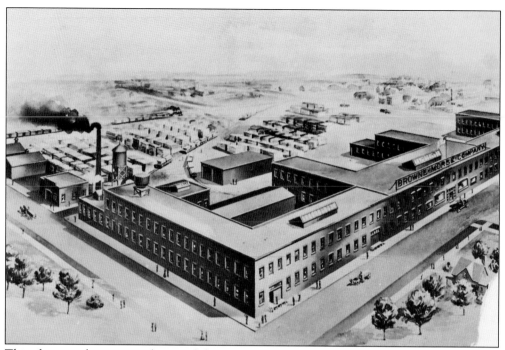

This photograph is an aerial view of the Browne-Morse Company, a maker of wood and steel office furniture for over 75 years. Browne-Morse was founded in 1907 by Frank Morse, a former executive of Shaw-Walker, and Richard Browne, a retired plumbing dealer.

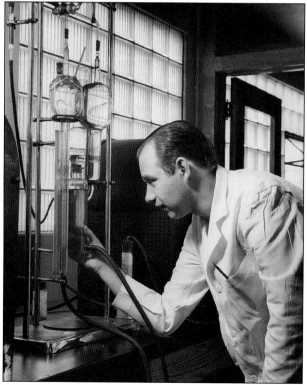

A member of the Lakey Foundry Metallurgical Laboratory is seen making a reading on a gray iron carbon determinator. Lakey was one of the largest gray steel manufacturers in the Midwest and was one of Muskegon's largest employers for over 50 years. During World War II, the company switched to defense work, but returned to manufacturing parts for the automotive industry and manufacturing after the war. Lakey closed in 1972 after filing bankruptcy.

A. Harold Frauenthal, the chairman of the board of the Kaydon Corporation, pictured on the left, looking at precision grinding equipment. Kaydon, the world's largest manufacturer of ball and roller bearings, was founded in 1941 and celebrated its 75th anniversary in 2016. The company was named for Frauenthal's children, Kay and Don.

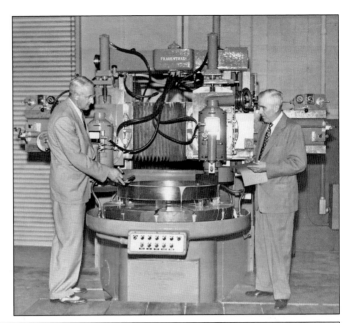

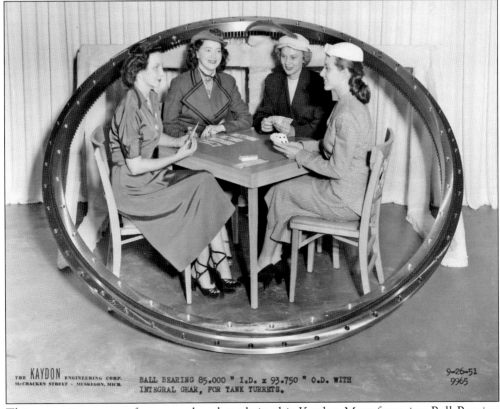

This attractive group of women played cards in this Kaydon Manufacturing Ball Bearing advertisement. Kaydon has manufactured bearings ranging in diameter from 2 to 72 inches for decades. This picture shows the four seated women encircled by the ball bearing, dramatically demonstrating its size.

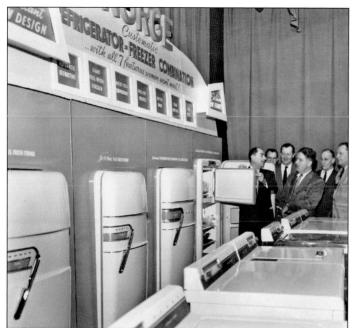

A salesman proudly shows onlookers a Norge refrigerator in the mid-1950s. Norge refrigerators were produced at Norge's Muskegon Heights plant, which employed 1,400 people in 1955. The company was a division of BorgWarner during the era this picture was taken.

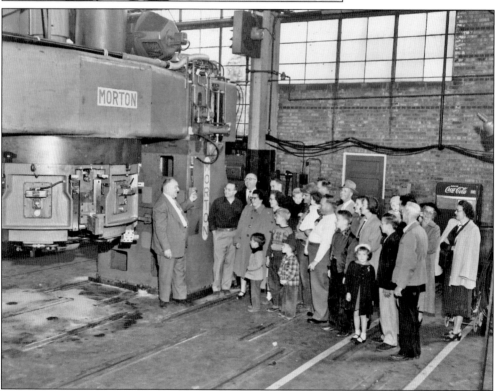

Earl Morton, president of Morton Manufacturing Company, stands in front of a group of people touring the plant. The metal-working machinery manufacturer was formed as Morton Valve Company by Matthew Morton in 1878, reorganized as Morton Manufacturing Company in 1878, and was moved to Muskegon Heights in 1891.

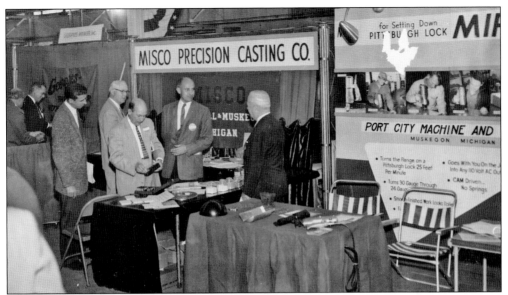

Men stand in front of the Misco Precision Casting Company booth during a trade show. Misco was formed in Whitehall in 1951 and is now Alcoa Howmet.

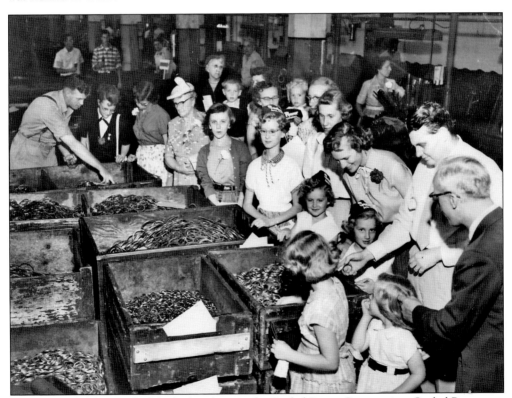

A group of children and adults look at bins at the Sealed Power Corporation. Sealed Power was founded as Piston Ring Company by Charles E. Johnson and Paul R. Beardsley in 1911 and became Sealed Power in 1931. The company was Muskegon's leading corporation and the only Fortune 500 Company in the community for many years.

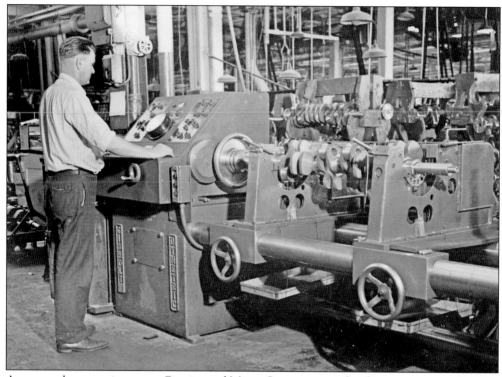

A man works on equipment at Continental Motor Company, a technology company with a long history in Muskegon. The technology company opened in 1905 and produced engines for aircraft. The Muskegon Getty Street Plant is now L-3 Combat Propulsion Systems.

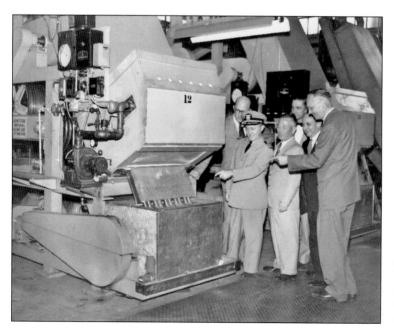

A military officer tours the Continental Motor Company with company executives. During both world wars, the company supplied vital products to the war effort.

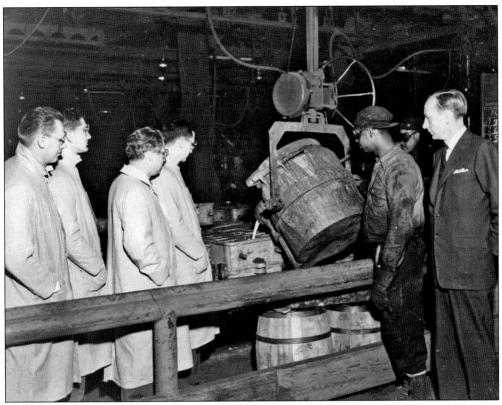

A group of men watch a man working at the Campbell, Wyatt & Cannon (CWC) Foundry Company. CWC manufactured engine blocks for Continental Motor Co. The Muskegon company was acquired by Textron Corporation in 1956.

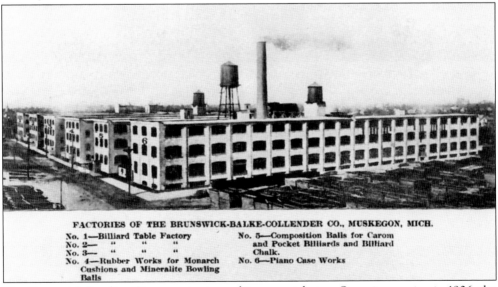

FACTORIES OF THE BRUNSWICK-BALKE-COLLENDER CO., MUSKEGON, MICH.

No. 1—Billiard Table Factory
No. 2— " " "
No. 3— " " "
No. 4—Rubber Works for Monarch Cushions and Mineralite Bowling Balls

No. 5—Composition Balls for Carom and Pocket Billiards and Billiard Chalk.
No. 6—Piano Case Works

The Brunswick Bowling Company is pictured in an aerial view. Since its opening in 1906, the bowling and billiards division of Brunswick Corporation was a prominent business leader and employer in Muskegon.

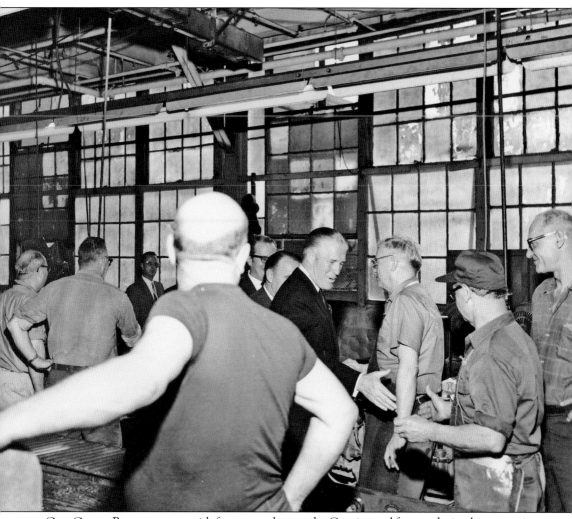

Gov. George Romney meets with factory workers at the Continental factory during his campaign visit to Muskegon in 1968.

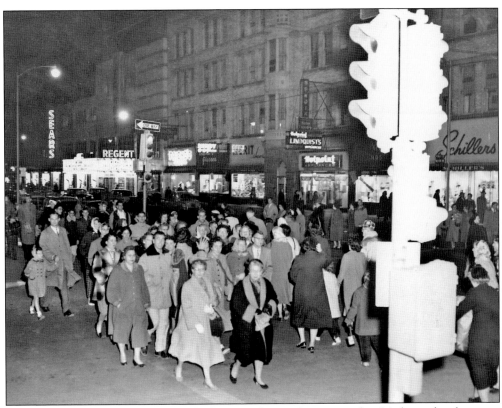

Downtown Muskegon was filled with shoppers during this winter day. Michiganders long ago learned they could not let a little inclement weather stand in the way of necessary errands.

When the downtown mall opened, shoppers no longer had to brave the elements and could now browse the stores in indoor comfort.

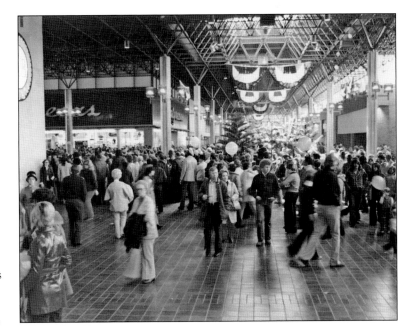

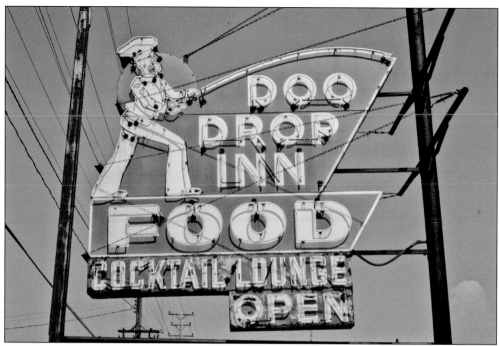

The Doo Drop Inn was long the restaurant of first choice for many locals and a must-do for visitors as well. While campaigning for president in 1960, John F. Kennedy did drop in. Whether he sampled the signature perch is unknown. (Courtesy of the Bentley Historical Library, University of Michigan.)

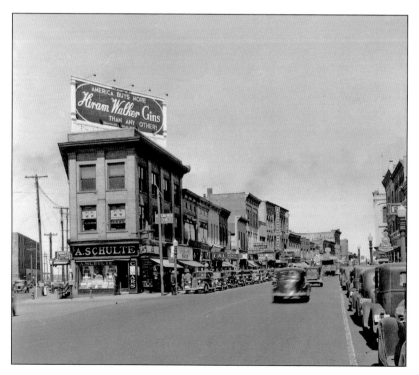

The Flatiron Building was a downtown icon until it was razed to make room for the new downtown mall. (Library of Congress.)

Four

CHURCHES AND SCHOOLS

Churches and schools are among the first indicators that a new frontier has been tamed. Early Muskegon settlers represented all denominations. The Catholics were first due to Fr. Frederic Baraga, a missionary to the area who converted some of the Ottawa people and also served the French Canadian fur traders.

Protestants followed, and Dutch immigrants, already a presence in the surrounding area, brought their Reformed and Christian Reformed faiths to Muskegon as well. In addition, there were Methodist, Baptist, Lutheran, Episcopal, Congregational, and Universalist congregations and a Jewish synagogue.

The city always took pride in its schools, which included the usual kindergarten through high school education and soon expanded to trade schools and college. Then and now, private schools run by various religious denominations offered an alternative.

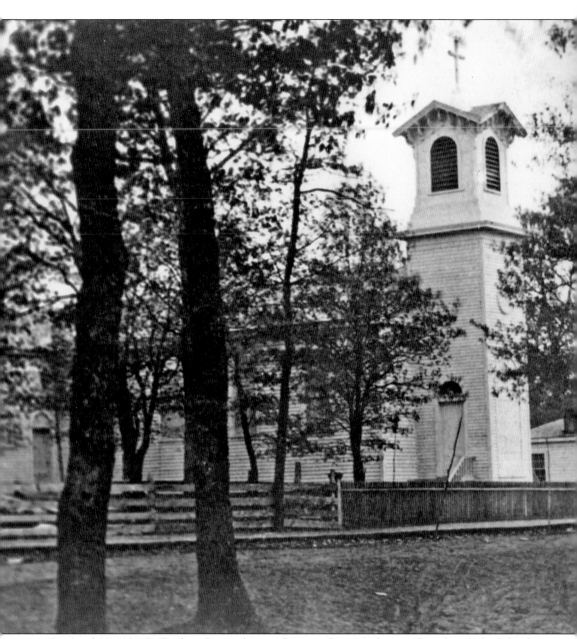

On April 20, 1834, Fr. Frederic Baraga baptized 21 people in Muskegon's first church, built by the Ottawas near Pigeon Hill. He blessed the crudely constructed building and dedicated it to St. Joseph. It was later replaced by St. Mary's Church, shown here, on Clay Avenue. Father Baraga eventually went to the Upper Peninsula, where he became known as the "Snowshoe Priest," as that was his mode of transportation in serving far-flung parish villages.

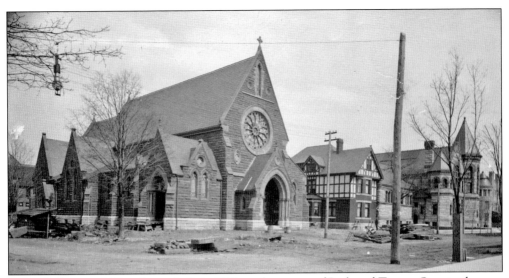

St. Paul's Episcopal Church was built in 1873 on the corner of Peck and Terrace Streets, the area now known as Kearney Park. The first service was held on Christmas day of that year, and the last service was held there on July 20, 1879. Five months later, in November 1879, services were held in the new building on Clay Avenue at Third Street (above). Church members and the community at large took pride in the beautiful stained-glass windows, as seen below.

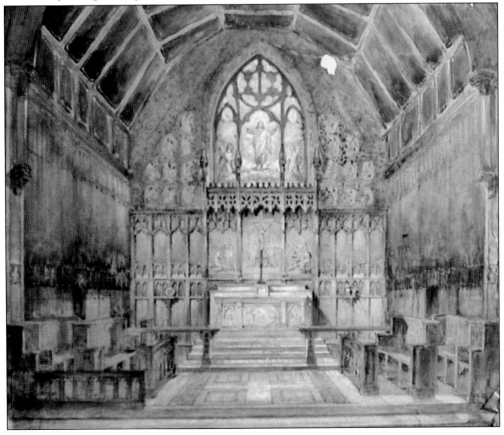

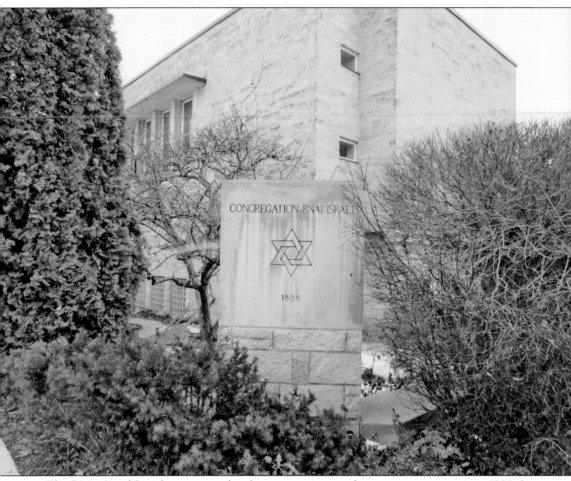

The B'Nai Israel Jewish synagogue has been a continuous downtown presence since 1888. It is still the only one in Muskegon and still going strong. The cornerstone from the original structure reminds all of its historic past. (Photograph by Norma Lewis.)

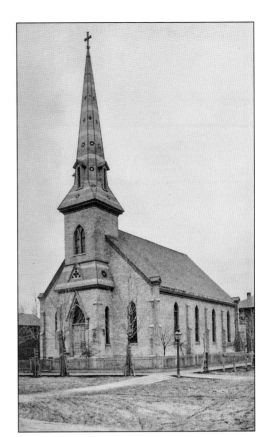

St. Joseph's Catholic Church on Fifth Street and Monroe Avenue started as a German Catholic church but dropped the German designation as the Catholic population became more diverse. The image below shows the church in 1993 looking much as did in the beginning.

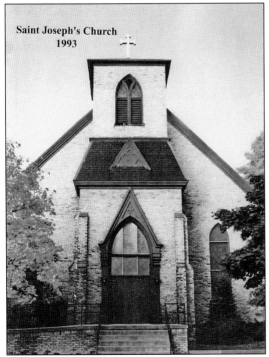

Saint Joseph's Church
1993

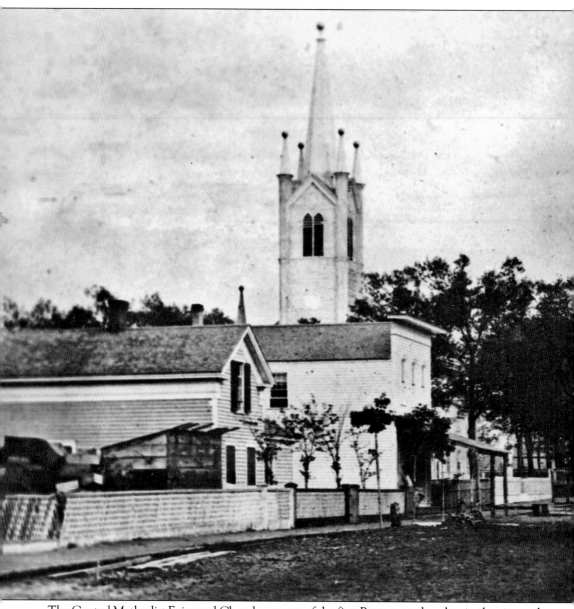

The Central Methodist Episcopal Church was one of the first Protestant churches in the city, and the wooden sidewalks shown here suggest that the photograph was taken prior to 1870.

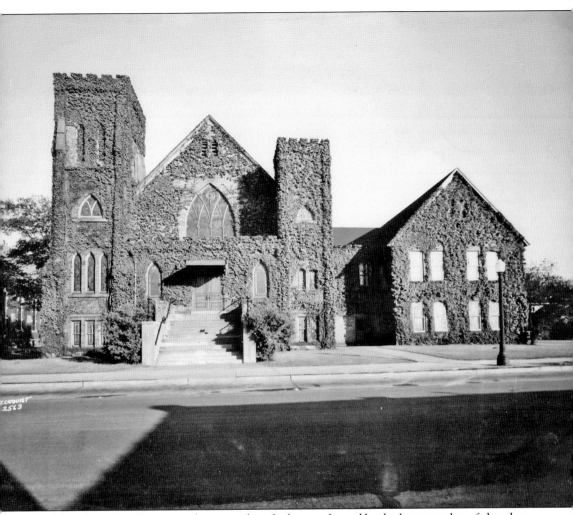

Early Muskegon residents were devout in their faith as evidenced by the large number of churches in the downtown area in the mid to late 1800s. Every denomination was represented. The First Congregational Church on the corner of Clay Avenue and First Street was dedicated in 1884. By 1914, the edifice needed to be enlarged and renovated.

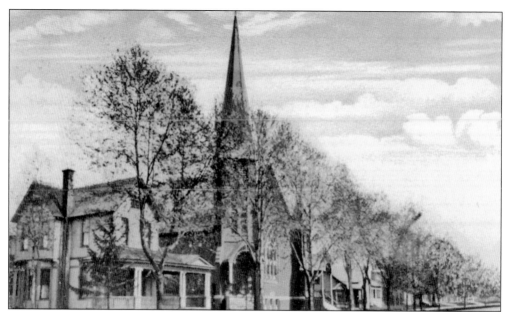

The First Christian Reformed Church in Muskegon was founded in 1867 and held its final service 146 years later on September 15, 2013. It was an emotional event for all, especially those whose roots there were several generations deep. (Courtesy of Heritage Hall Archives at Calvin College.)

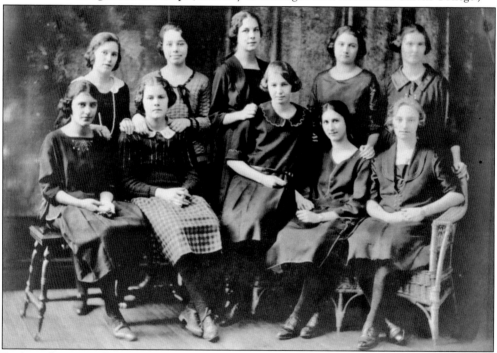

Back in the 1920s, few women worked outside the home, leaving them with time to devote to schools, churches, and other community needs. These ladies were members of the First Christian Reformed Church's Mission Circle. All denominations had such organizations and no doubt depended on the hard work of their female membership. (Courtesy of Heritage Hall Archives at Calvin College.)

The Universalist faith also thrived and built its church on Third Avenue and Clay Street. In 1961, the Unitarian and Universalist congregations merged to become the Unitarian Universalist Association. Muskegon's UUA congregation is located at 1296 Montgomery Avenue.

The historic St. Jean Baptiste French Catholic Church, established in 1883, is pictured in 1888. The congregation merged with St. Mary's Catholic Church, and the building was closed in 2015. Bishop Marvin Sapp, of gospel music fame, reopened the church as Lighthouse Full Life Center in 2017.

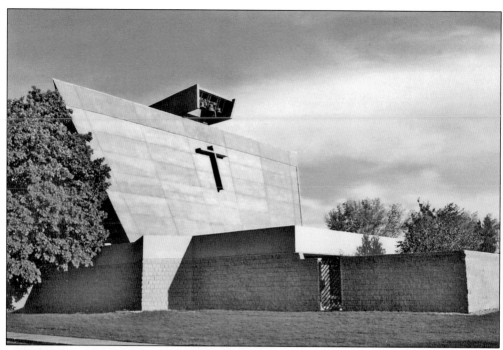

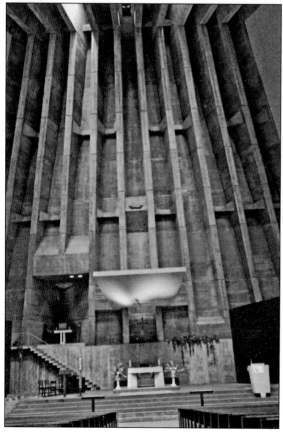

Area churches shared a traditional style until 1966, when the new St. Francis de Sales Catholic Church was built on McCracken Street in Norton Shores. "Stunning in its simplicity," was one of the many rave reviews received. The interior (left) was a bit more traditional but still on the cutting edge.

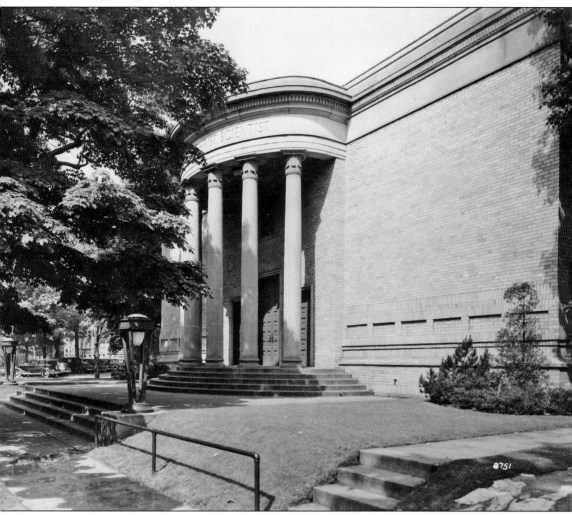

The Christian Science faith was first practiced in Muskegon in 1884, after Dudley Tillotson, who had been ill for most of his life, was healed by a woman who had studied under Mary Baker Eddy. After meeting for years in members' homes or the Muskegon Women's Club, the congregation moved, in 1931, into this Greek Revival edifice and officially became the Church of Christ, Scientist.

The renowned Maranatha Bible and Missionary Camp and Conference Center became a reality when Rev. Dr. Henry Savage recognized a need. It opened in 1938 under the management of Howard Skinner, a Methodist minister, and continues to experience steady growth. Its growing reputation attracted prominent speakers, including Billy Graham, who appeared six times in the mid-1940s and early 1950s. Skinner and his wife, Ada, graced a Maranatha postcard in 1954. (Courtesy of Norma Lewis collection.)

Continued expansions over the years, including condominiums, have resulted in a modern facility that would rival any resort. (Courtesy of R. Schulenburg.)

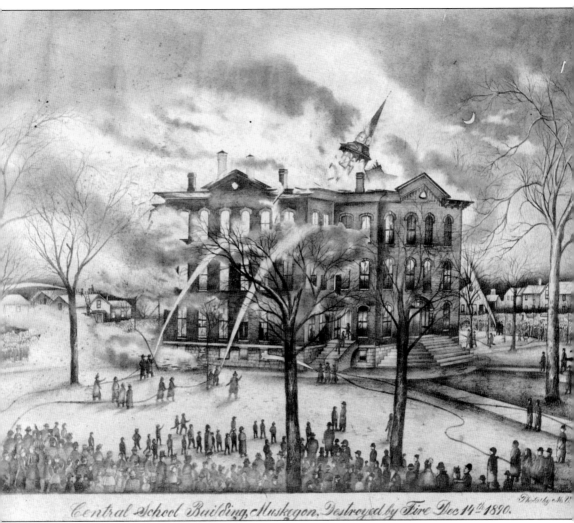

Central School Building, Muskegon, Destroyed by Fire Dec 14th 1890.

This image shows the Central School, built in 1875 on the site formerly occupied by the Union School. It was considered a beautiful addition to the city until, sadly, it was destroyed by fire on December 14, 1890. It later became the site of the Hackley School, yet another contribution Charles Hackley made to the city he loved.

The kindergarten class poses outside the school during recess at the old McLaughlin School. It was the first school in the area to offer kindergarten.

The Angell School, sometimes referred to as the Apple School, located at Apple Avenue and Chestnut Street, was torn down in 1931. It was named for the revered educator, administrator, and diplomat James Burrill Angell, who held the distinction of being the longest-serving president of the University of Michigan. His tenure began in 1871 and ended when he died in his home on campus in 1909.

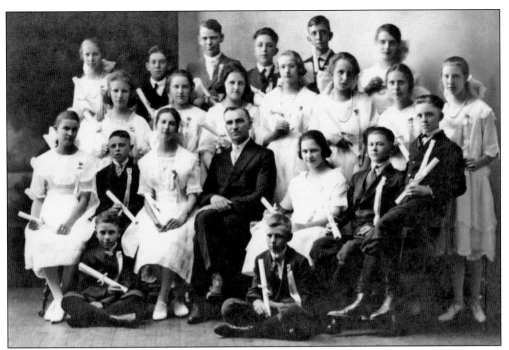

Muskegon Christian School's class of 1921 poses for a formal graduation photograph with their principal. As an alternative to the public school system, members of various denominations including Catholic, Christian Reformed, and Lutheran have long felt the need to provide a religious education for their children. (Courtesy of Heritage Hall Archives, Calvin College.)

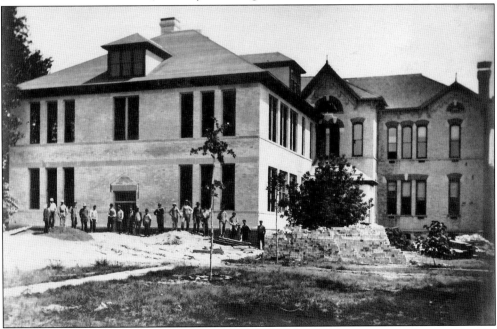

McLaughlin School students are leaving their classrooms behind to enjoy the outdoors. Originally named the Ransom School, it was renamed to honor longtime school board member David McLaughlin in 1891. The school closed in 2012 after serving the community for 129 years.

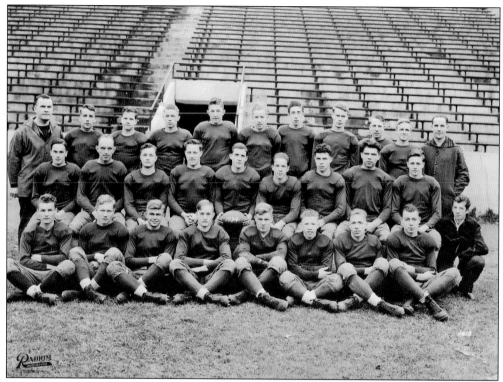

Does anything capture high school pride more than a football team? Muskegon High School's Big Red varsity team of 1934 poses for a yearbook picture at the school's athletic field named for Charles Hackley.

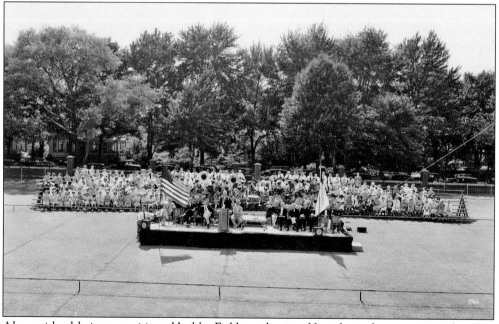

Along with athletic competitions, Hackley Field was the site of first choice for concerts, graduations, and other outdoor celebrations.

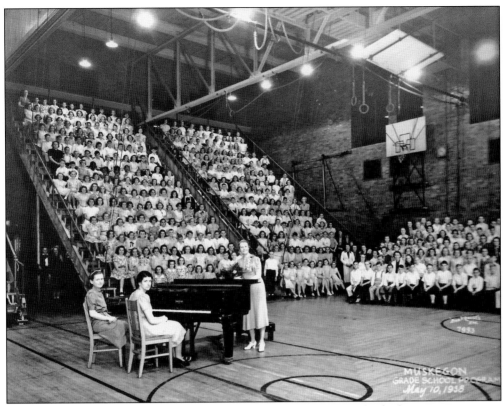

Scenes like this 1934 program at the Muskegon Grade School bring back pleasant memories to those who have participated in such events and have proudly watched their children display their talents. (Courtesy of Norma Lewis.)

The Urasaline Academy closed after being acquired by the board of education, which reopened it on December 21, 1920 with a new name: the William H. Wilson School.

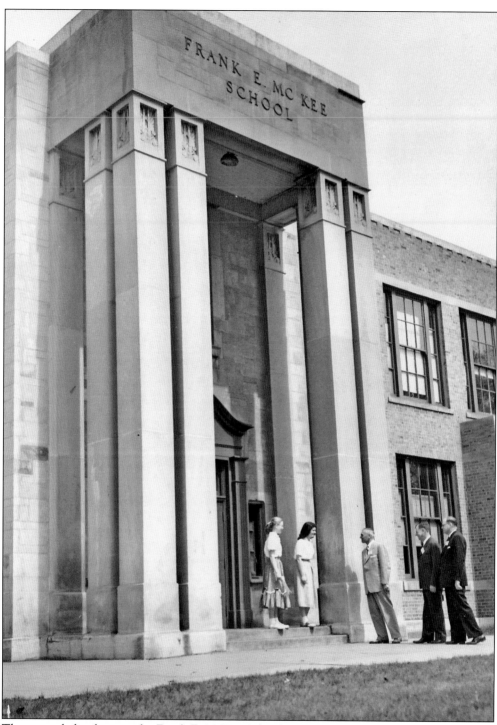

The young ladies leaving the Frank E. McKee School at 1600 Mills Road in North Muskegon are greeted by three unidentified gentlemen.

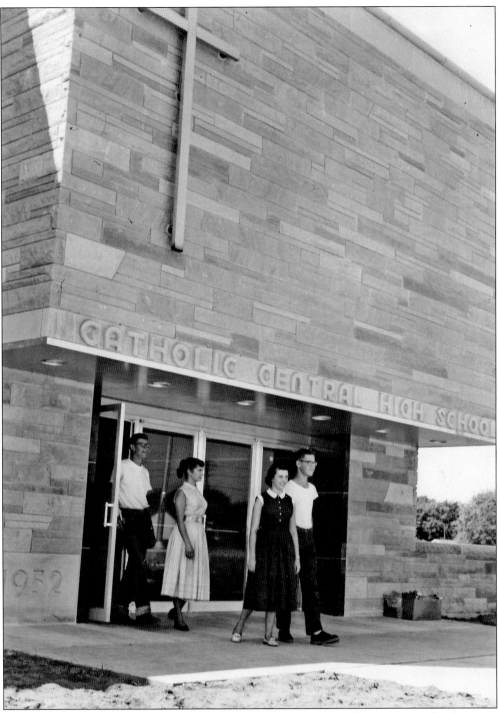

Striking a pose similar to the preceding page, this foursome is strolling out into a lovely spring day at the Catholic Central High School on Laketon Avenue, also in the 1950s. Missing are the uniforms traditionally worn by Catholic students.

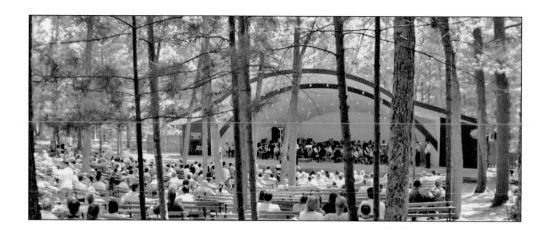

The renowned Blue Lake Fine Arts Camp offers student campers instruction and a venue in which to perform. Performances included vocal and instrumental concerts and plays like the lavishly costumed Shakespearean production shown below.

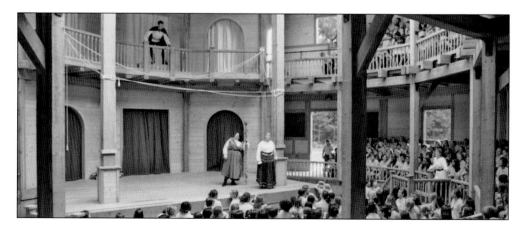

Five

Everyday Life in Muskegon

The burgeoning settlement on Lake Michigan and Muskegon Lake needed services and community-minded citizens rose to the challenge. The first fire department, named for Charles Hackley, consisted of volunteers. Firemen had no fancy trucks or equipment and relied on horses for transport to engage in what was little more than a bucket brigade.

Policemen kept order though there was not a great deal of major crime. Except in times of financial recessions, jobs were plentiful, and most of those morally upright men preferred working to stealing. Postmen delivered mail, and boys on bicycles delivered telegrams and newspapers. The fact that all those job titles ended with "men" is how it was. Men and women had different responsibilities and seldom got in each other's way.

Evenings out meant anything from theater to opera, to vaudeville, and if dining out was part of the agenda, there were ample choices. Eventually, movies became part of the mix.

Early residents worked hard, and when the rare opportunity presented itself, they played hard, too. Companies began forming athletic teams to compete with one another as a way of building camaraderie among workers and company loyalty. Locals loved both spectator and participatory sports. They bowled, golfed, swam, and ice-skated. Muskegon also sent a number of athletes to the major leagues in baseball, football, and hockey.

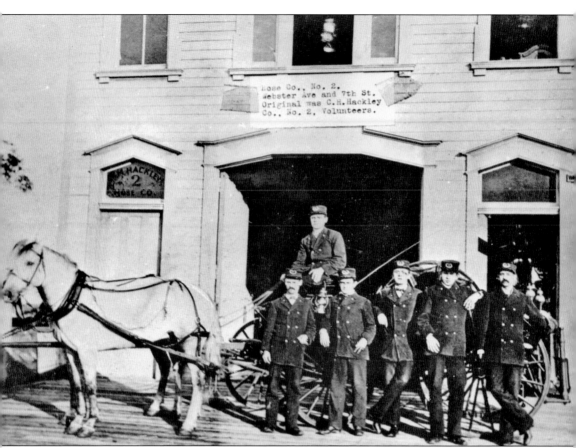

Above, volunteer firefighters from C.H. Hackley No. 2 Hose Company, on the northwest corner of Webster Avenue and Seventh Street, proudly stand with what was considered state of the art in the 1880s. By 1909, the Muskegon Fire Department had several horse-drawn fire trucks.

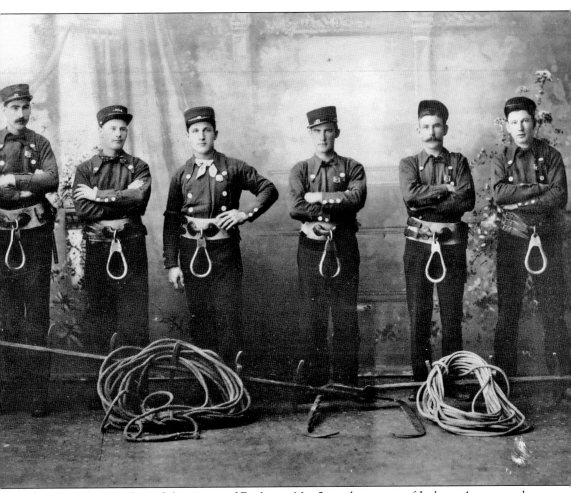

On the unknown date of this image of Firehouse No. 5 on the corner of Jackson Avenue and Yuba Street, the city still had no motorized vehicles. Firefighters in uniform with equipment on their belts and ropes are ready for action.

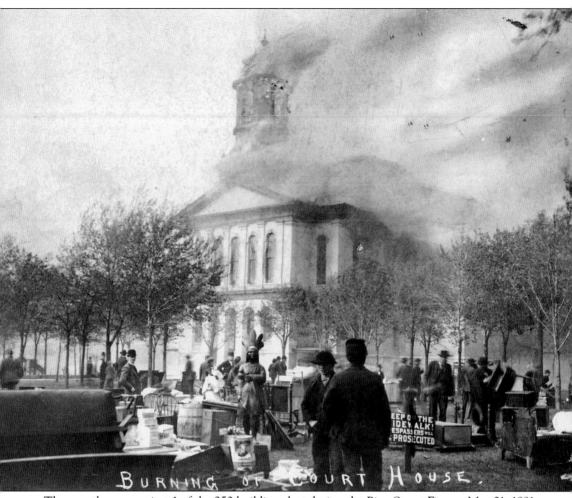

BURNING OF COURT HOUSE.

The courthouse was just 1 of the 250 buildings lost during the Pine Street Fire on May 21, 1891. The image below shows more destruction from that fire, which destroyed 17 city blocks at a cost that would exceed $12 million today.

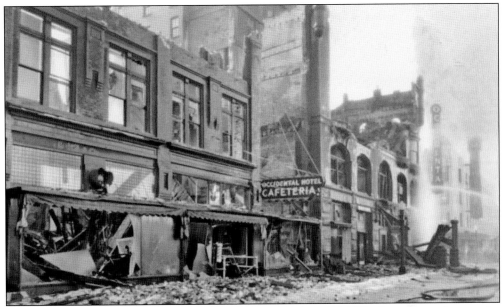

Later fires included one at the Occidental Hotel on March 4, 1936. The Pine Street fire was the city's second most costly. The worst was the fire beginning in a store owned by William D. Hardy that quickly escalated into a blaze that destroyed two-thirds of the block and would cost about $17 million in present-day dollars. Among the destroyed buildings were Hardy's, Neumode Hosiery, Daniels, Mangels, Wright Jewelers, Krautheim Jewelers, Buel's Shoes, and Walgreens.

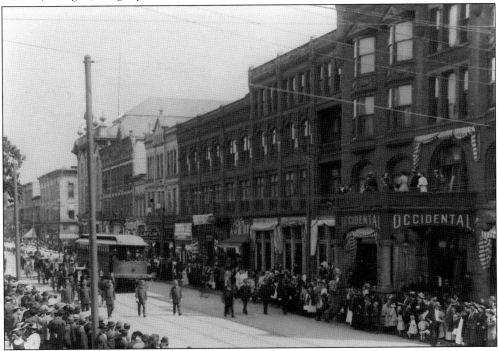

Spectators watch as marchers in a Labor Day parade pass historic buildings on Western Avenue, including the Old Opera House, which was later the Elks Temple, and the Occidental Hotel. The parade included Grand Rapids, Grand Haven & Muskegon Company Railway Car No. 13.

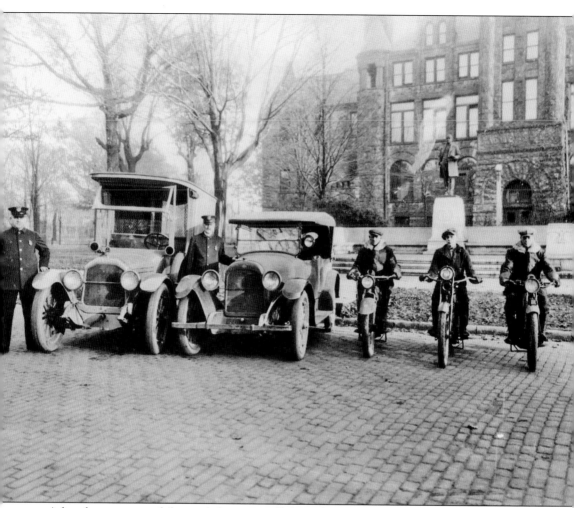

A handsome group of the city's finest are all dressed up in their spiffy uniforms and ready to do battle in the war on crime. With an up-to-date and polished fleet of automobiles and sporty motorcycles to chase them down, the bad guys would not stand a chance. Behind the motorcycle officer in the middle is a statue of Pres. William McKinley. It was unveiled six weeks after the president's assassination to a crowd of 50,000 on Memorial Day, 1902.

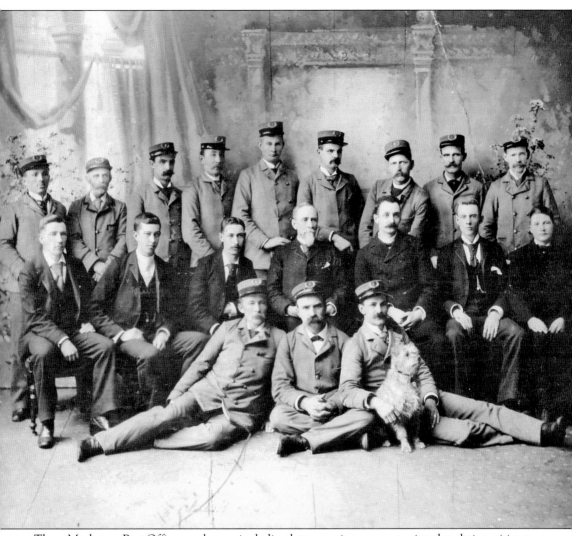

These Muskegon Post Office employees, including letter carriers, were appointed to their positions between 1887 and 1892 and pose with their mascot. It is unknown when the mascot was appointed or by whom.

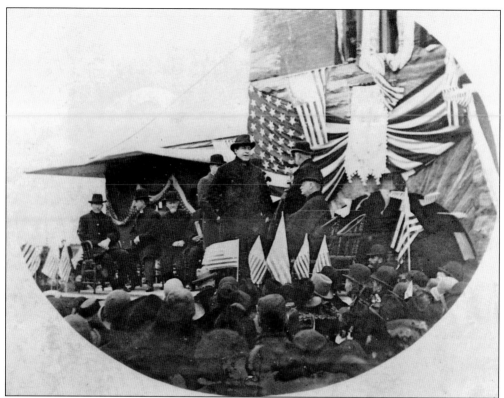

The Union Depot (above) opened for business in 1895. The following year, thousands gathered there to hear a campaign speech by William Jennings Bryan, the Democratic presidential candidate. Bryan lost the election to Republican William McKinley. He followed with two more presidential bids but lost both times.

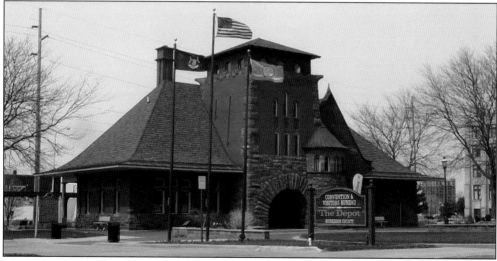

The historic 1895 Union Depot is a fine example of Richardsonian Romanesque Revival architecture (named for architect Henry Hobson Richardson) and is listed in the National Register of Historic Places. The former railroad station now serves as the site of the Muskegon Convention and Visitors Bureau. (Photograph by Christine Nyholm.)

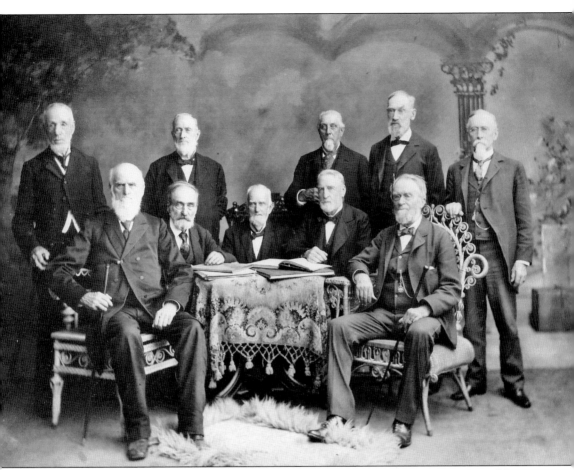

The Muskegon Grand Old Men club gathered for a formal studio portrait in 1900. Seated from left to right are (first row) George B. Woodbury, J.D. Davis, William McKillip, C.T. Hills, and S.H. Stevens; (second row) A. Gustin, E.W. Merrill, George J. Tillotson, Luthor Whitney, and Hiram Barker.

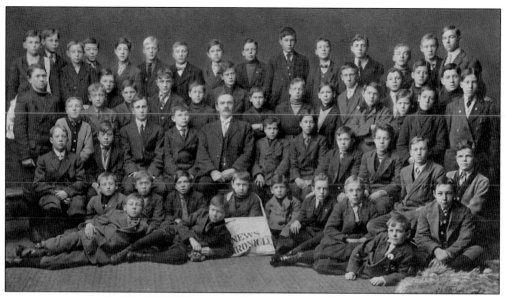

The *Muskegon Chronicle* relied on this serious-looking group of boys to deliver the newspaper to all who subscribed. As of 2018, the paper has been in business for 161 years.

Ruth Thompson was a trailblazer. Born in Whitehall in 1887, the Republican worked as a lawyer before becoming the first woman to hold an elective position in Muskegon County. She followed that by election to the Michigan House of Representatives in 1939. Thompson's next served three terms in the US Congress representing the Ninth District. Between her state and national terms of office she held several nonelective government positions at both state and national level.

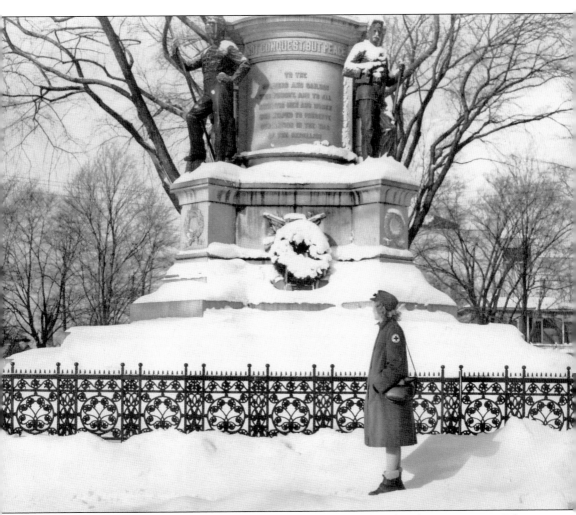

Muskegon residents joined the rest of the country in doing their bit during wartime. This unidentified woman stands in front of the center statue in Hackley Park. The 80-foot-tall Soldiers and Sailors Monument was erected in memory of veterans of the Civil War and was presented to Muskegon by lumber baron and philanthropist Charles H. Hackley in 1890. Statues of Farragut, Sherman, Grant, and Lincoln grace the corners of the park.

"Jumping Joe" Beyrle is the only known American to have served in both the Russian and American armies in World War II. Both deemed him a hero. His convoluted story began when he enlisted in the 506th Parachute Infantry Regiment of the 101st Airborne's Screaming Eagles. He was captured by Germans, escaped the prisoner-of-war camp, and ended up in Moscow, where he was recruited to serve in a Soviet tank battalion. (Courtesy of the Lakeshore Museum Center.)

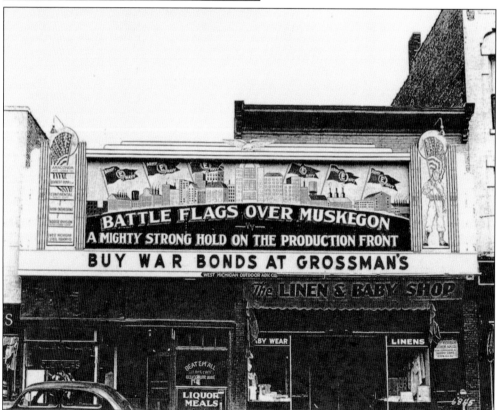

Flags over Muskegon was the theme of a war bond sales drive held at Grossman's Department Store. Patriotic citizens scrambled to buy them, not only to help their country, but also to invest some money.

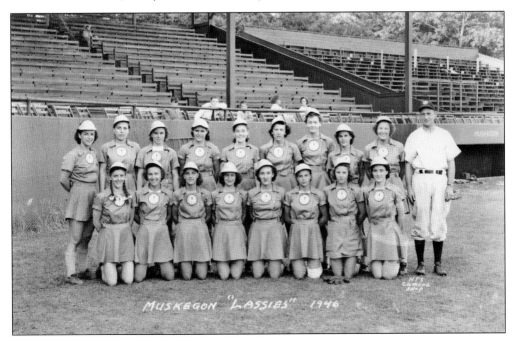

1947 MUSKEGON LASSIES

1947 MUSKEGON LASSIES • *Standing, left to right:* Bill Wamby (manager), Jo Lenard, Nancy Warren, Pat Barringer, Kate Vonderaw, Marian Watson, Alva Jo Fischer, Doris Sams, Erma Bergman, Dorothy Maguire, Helen Hannah (chaperone). *Seated:* Delores Siegfried, Arlene Johnson, Irene Applegren, Evelyn Wawryshyn, Dorothy Stolze, Sara Reeser, Donna Cook, Charlene Pryer.

The Muskegon Lassies were the local team of the All American Girls Professional Baseball League made famous in the 1992 movie *A League of Their Own.* The league came about during World War II because Chicago businessman and Chicago Cubs owner Philip K. Wrigley worried that with fewer men around to play, baseball fans would lose interest in the sport before games were resumed. It also provided fun for the sports-loving public, who cut the ladies a bit of slack. One male fan commented, "They lost. So what? They're still cute."

MUSKEGON "LASSIES" 1946

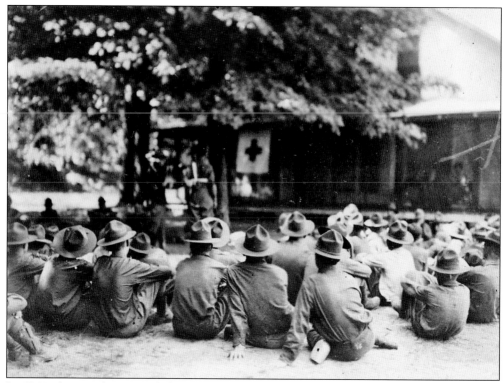

In 1944, these cadets attended a first-aid lecture at Muskegon's Camp Roosevelt. A unique program, inaugurated in Muskegon in 1920, allowed the American Red Cross to provide first-aid and hospital services while providing first-aid training at the same time. (Courtesy of the Library of Congress.)

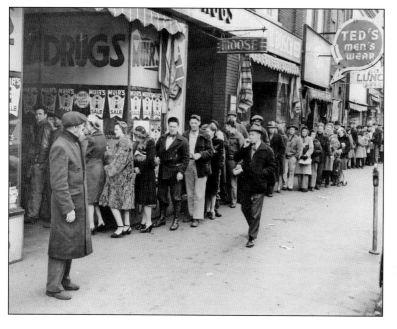

Back in the day, when smoking was considered cool, Muir's Drug Store management knew a sure way to bring a crowd into their store was to offer a sale on cigarettes. The long lines stretched out on both sides of the entrance.

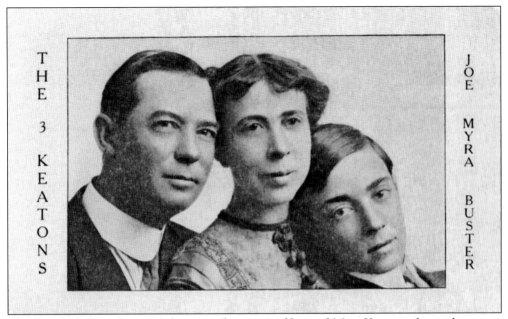

The famed Bluffton Actors' Colony was the genius of Joe and Myra Keaton, who, with a group of like-minded performers, founded the organization. Their son Buster (shown here) honed his comedic skills here while still a child before hitting the big time in silent films.

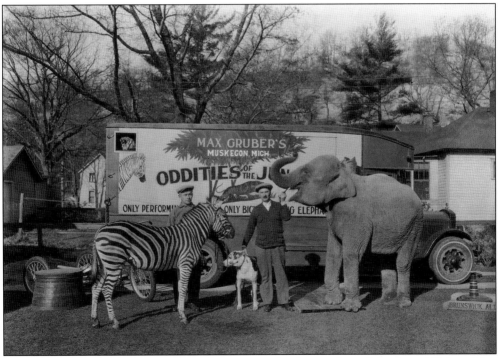

Even among the variety of vaudeville-style acts put on by the members of the Actors' Colony, Max Gruber's stood out. He called it Oddities of the Jungle, and it included an elephant named Little Eva, who, among her other talents, could ride a tricycle. His other "oddities" were a zebra and a Great Dane, both of whom also loved performing. (Courtesy of the Lakeshore Museum Center.)

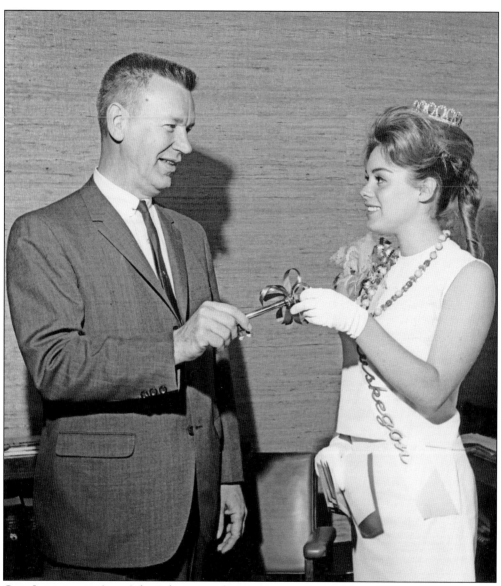

Gary Larcom was Ann Arbor's first city administrator and served from 1956 to 1973. During a 1964 visit to Muskegon, he received a ceremonial key to the city. (Courtesy of the University of Michigan, Bentley Historical Library.)

Not all who traveled to the Muskegon lakeshore stayed in the resorts. Some preferred camping. (Courtesy of Norma Lewis collection.)

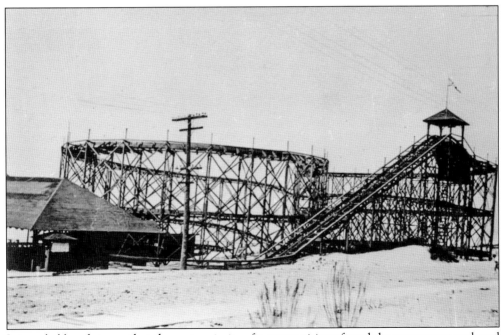

It is probably safe to say that the vast majority of summer visitors found the amusement park and roller coaster whether their accommodations were a resort, a roadside motel, a campground, or simply bunking in a relative's spare bedroom.

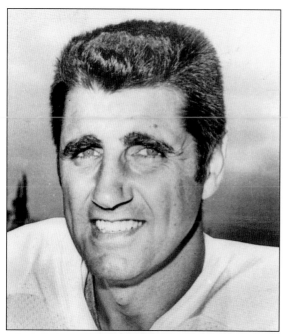

National Football League quarterback Earl Morrall began his athletic career when he led the Muskegon High School Big Reds to the state championship in 1951. From there, he went on to play on Michigan State University's Rose Bowl winning team in 1956. He was first-round draft pick by the San Francisco 49ers. In his 21 professional seasons, he also played for the Baltimore Colts, Miami Dolphins, Pittsburgh Steelers, New York Giants, and Detroit Lions. This image was published in 1976. (Courtesy of the *Chicago Tribune*.)

Second baseman Bobby Grich spent six years playing with the Baltimore Orioles and nine with the California Angels. Though he had other offers, he chose the Angels because his parents would be able to watch him play. After knee damage, he retired but continued working for the Angels in community relations. In his free time, he golfs and skis.

Nate McLouth was born in Muskegon and attended Whitehall High School, where he developed his baseball skills to the point of winning the state Gatorade Player of the Year Award in 1999–2000. He went on to play outfield for the University of Michigan before playing professionally for the Pittsburgh Pirates, Baltimore Orioles, Atlanta Braves, and Washington Nationals.

The Muskegon Fury hockey team won the 2002 Colonial Cup Championship. Their hard-fought victory happened when Todd Robinson (center) scored a breakaway goal in overtime. (Courtesy of the Muskegon Lumberjacks.)

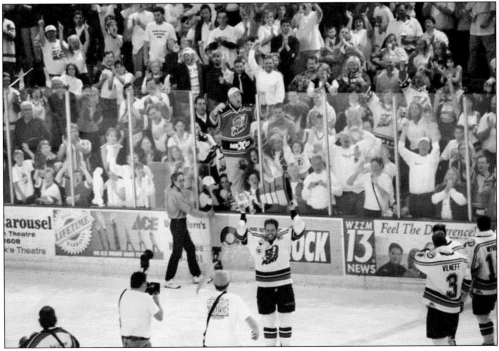

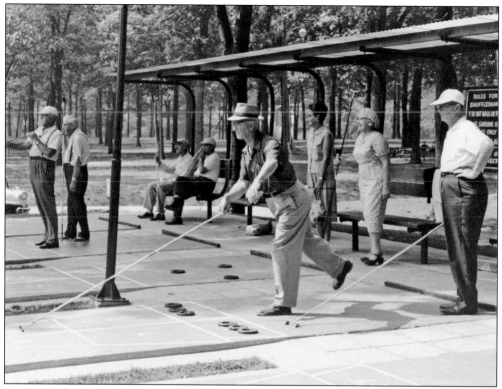

Muskegon people love their sports, both as spectators and participants. Parks are where people gather to socialize and engage in their favorite games. McGraft Park has a shuffleboard court that was a popular spot to spend a summer afternoon with friends.

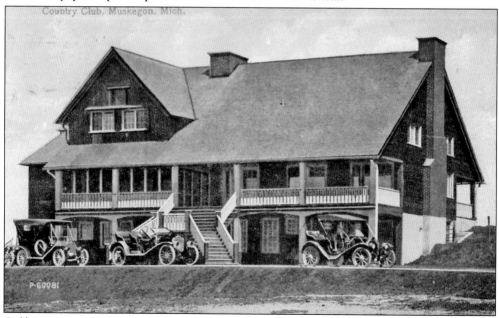

Golfers enjoying the privilege of membership always found a well-groomed course at the Muskegon Country Club. Public courses offered an alternative.

Hackley Park has been a favorite place to see and be seen, as these dapper gentlemen suggest. It is uncertain as to whether they were on their way to an elegant engagement or simply wanting to watch the girls go by.

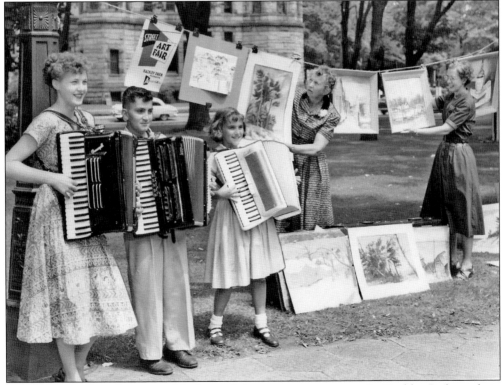

Youthful accordion players stand in front of the veterans monument in Hackley Park, ready to play their music as ladies hang works of art on a line at an Art Fair. Based upon their clothing, the photograph appears to be from around the 1950s.

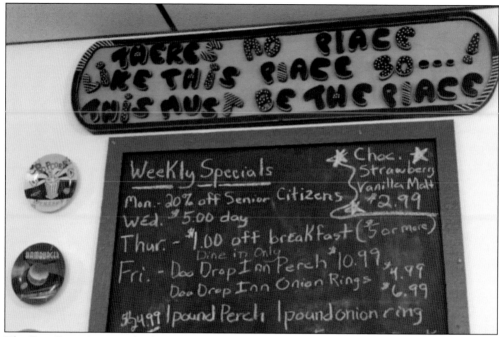

The Doo Drop Inn may be long gone, but two of the restaurant's favorites live on at Tootsie's Diner. Tootsie's owners, Julie Steffens and Amy Hargrove, serve the same perch and onion rings made from recipes given them by the Denslow family that owned the Doo Drop Inn. Family members check in periodically to make sure both menu items maintain the quality that made them a local legend. (Courtesy of Julie Steffens.)

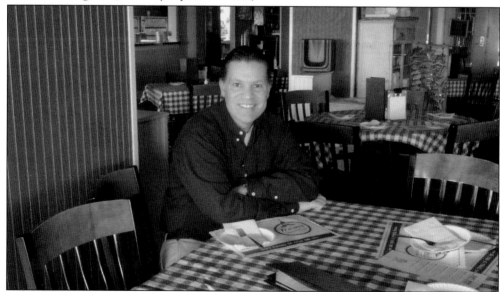

Another local favorite is Fricano's, the first pizza shop in Southwest Michigan in 1949. The first restaurant was in Grand Haven and is still going strong. Fricano's is still family-owned and headquartered in Muskegon with shops there and also in the Grand Rapids area. Ted Fricano, son of the founder, Gus, enjoys a quiet moment before opening for the evening. (Photo by Christine Nyholm.)

Muskegon County claims two Miss Americas. The first title went to Nancy Anne Fleming of Montague in 1961, who had entered and won the Miss Michigan event as Miss White Lake. Fleming graduated from Michigan State University and, after her reign, worked as cohost on the Lifetime cable network. (Courtesy of the Norma Lewis collection.)

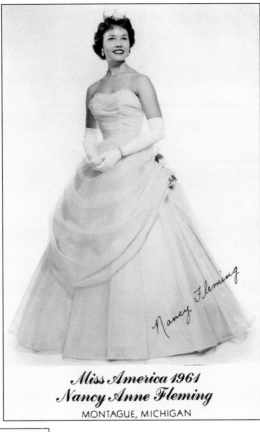

Miss America 1961
Nancy Anne Fleming
MONTAGUE, MICHIGAN

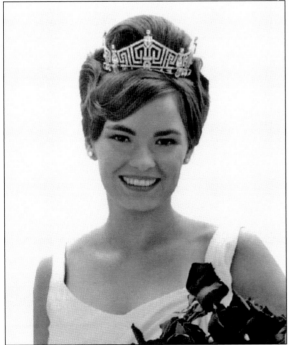

The second beauty queen, Vonda Kay Van Dyke, was born in Muskegon but was a college student in Arizona at the time of the 1965 pageant and entered as Miss Arizona. Van Dyke was the first—and so far, only—winner to also be voted Miss Congeniality. She also is the only winner whose talent was a ventriloquism act. Her costar's name was Kurley-Q. (Courtesy of Craig A. Hurst.)

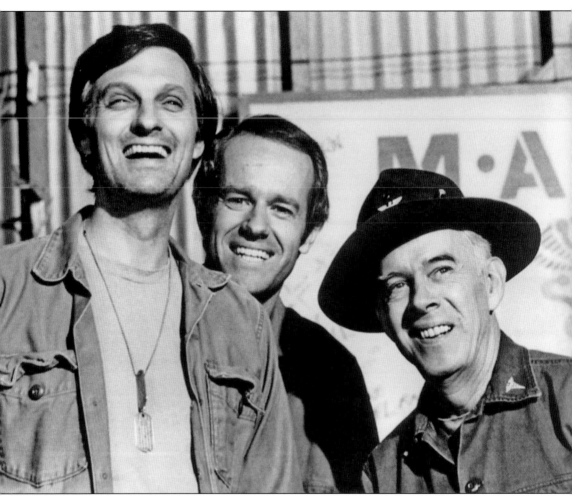

Among Muskegon's most beloved former residents is actor Harry Morgan, who, over several decades, played various roles including Bill Gannon, Sgt. Joe Friday's sidekick on *Dragnet*. The Muskegon High School graduate's real name was Harry Bratsburg, and he is probably best remembered as Col. Sherman Potter on *M*A*S*H*. (Courtesy of CBS Television.)

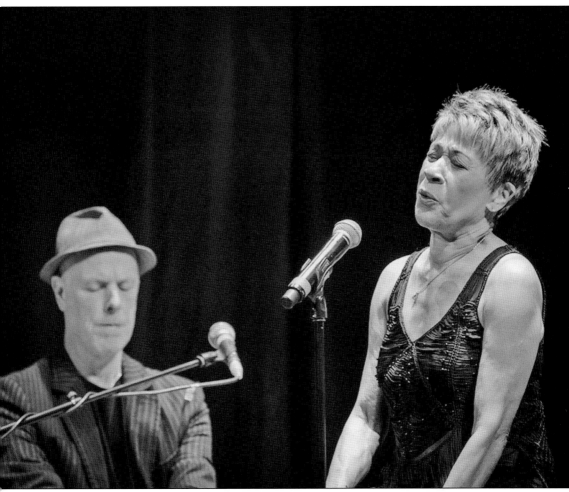

Bettye LaVette is a soul singer and songwriter. She was born in Muskegon and grew up in Detroit, where she cut her first record at age 16. Her career mostly languished, with occasional bursts of activity until after 2001, when she was rediscovered to critical acclaim. (Courtesy of the Library of Congress.)

NBA heavyweight Don Nelson first enjoyed fame as a Boston Celtics forward on championship teams in 1966, 1968, 1969, 1974, and 1976. He then went on to become one of the winningest coaches for the Milwaukee Bucks, New York Knicks, Golden State Warriors, and Dallas Mavericks. (Photograph by Sean P. Anderson.)

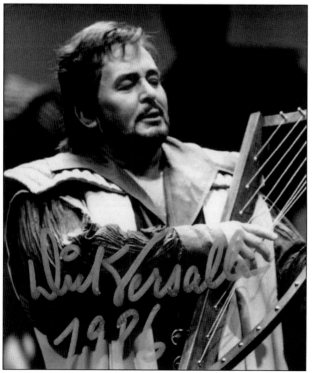

Richard Versalle was an opera singer better known in Europe than in the United States. He died on January 5, 1996, while playing the role of Vitek in *The Markopulos Case* at the Metropolitan Opera House in New York after suffering a heart attack while atop a six-foot ladder. He had just delivered the line, "Too bad you can only live so long." (Library of Congress.)

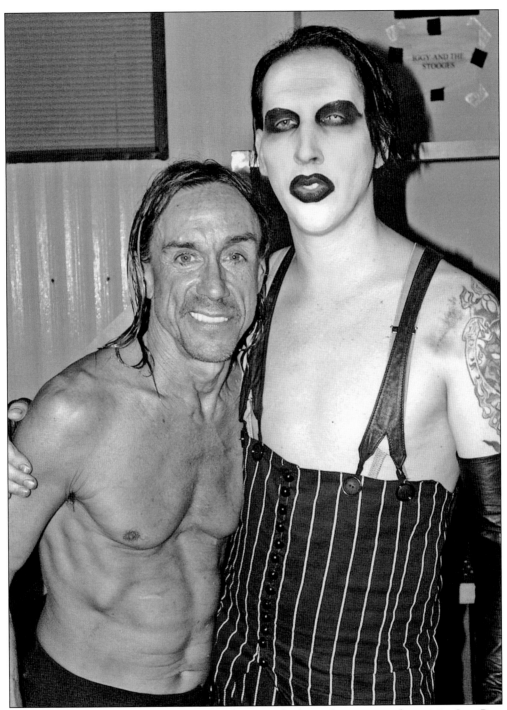

James Newall Osterburg Jr. was born in Muskegon and is better known as rock musician Iggy Pop. He has been performing since 1960 and made a name for himself as vocalist, songwriter, producer, and actor. He has been called the godfather of punk, and with the Stooges, he introduced the proto-punk genre for which he was inducted into the Rock Hall of Fame. He is pictured here on the left with Marilyn Mason. (Courtesy of Nicholas Broussard.)

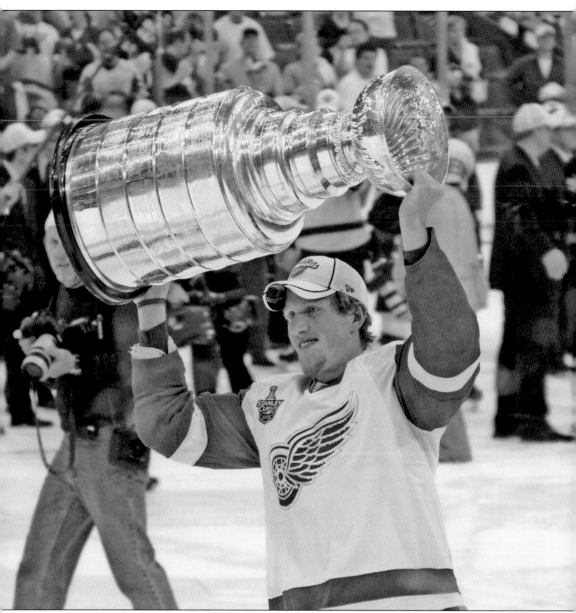

The Red Wings may be a Detroit team, but hockey fans across the state love them. They also love the Muskegon-born man wearing jersey No. 8, Justin Abdelkader, left wing and alternate captain. He graduated from Michigan State University and has played with the Wings since 2008. (Courtesy of Michael Righi.)

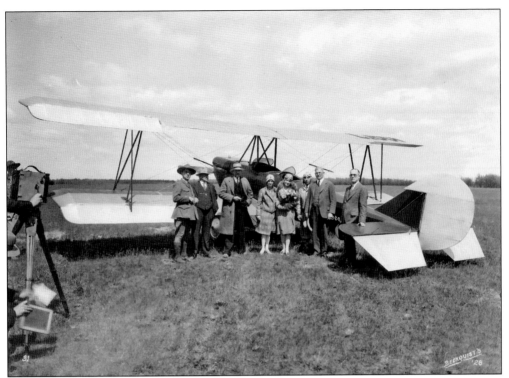

By the mid-1920s, it was gradually becoming accepted that people really could fly. The group shown here at the county airport obviously had not bought into the "if God had wanted us to fly, he'd have given us wings" mindset still held by some and were ready to embrace the latest fad.

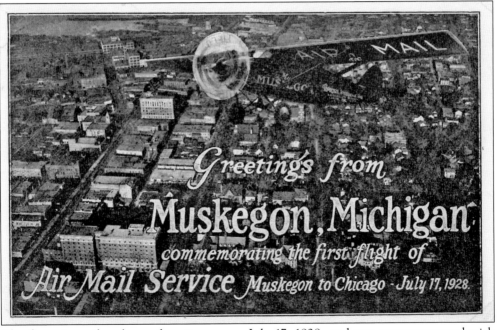

Greetings from Muskegon, Michigan commemorating the first flight of Air Mail Service Muskegon to Chicago - July 17, 1928.

The first air mail to leave the city was on July 17, 1928, and was commemorated with this postcard.

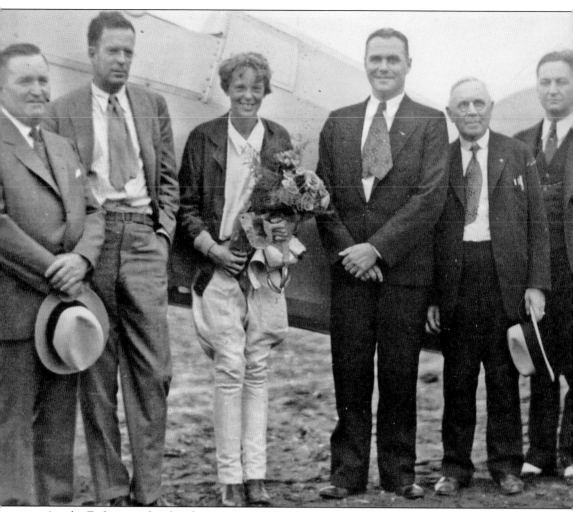

Amelia Earhart made a brief appearance in Muskegon on September 10, 1937. Upon arrival at the Muskegon County Airport, she was given a bouquet of flowers. Posing with her are, from left to right, Muskegon vice mayor George D. Vanderwerp; Earhart's husband, George P. Putnam; Earhart, Muskegon Heights mayor Martin Schoenberg; and two unidentified gentlemen.

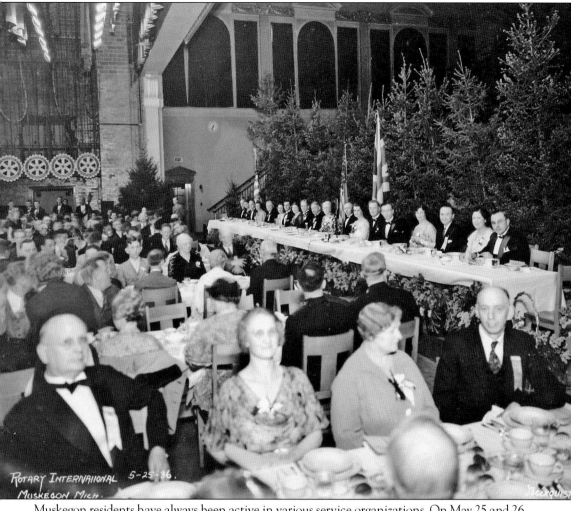

Muskegon residents have always been active in various service organizations. On May 25 and 26, 1936, the city's Rotary International Club members hosted the division conference. It appears to have been a gala event that was enjoyed by all those in attendance.

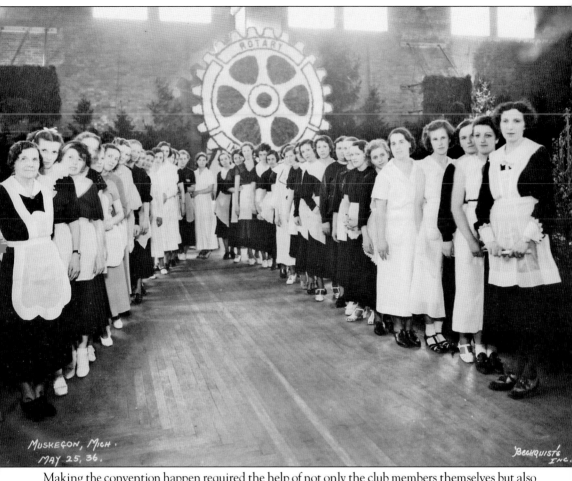

MUSKEGON, MICH.
MAY 25, 36.

BECKQUIST'S
INC.

Making the convention happen required the help of not only the club members themselves but also many others like these servers, who made sure all food was presented promptly and efficiently.

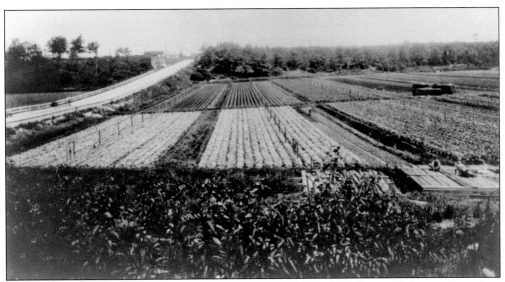

Farming was never as big an industry here as in some parts of Southwest Michigan, but celery farms, such as the Fisher family enterprise, flourished, and the surrounding area is noted for its exceptional fruit. Apple and peach orchards along with blueberry farms provided much appreciated treats for locals and visitors alike. (Courtesy of Heritage Hall, Calvin College Library.)

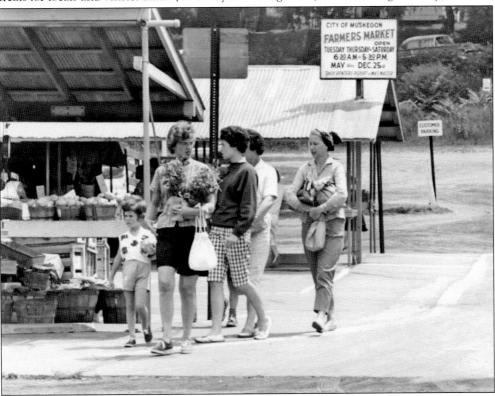

Muskegon has had a farmers market since 1921, though it was first called the city market. It is still a popular downtown destination all summer long. Along with the outstanding fruit and other local produce, patrons can find baked goods, flowers, crafts, and much more.

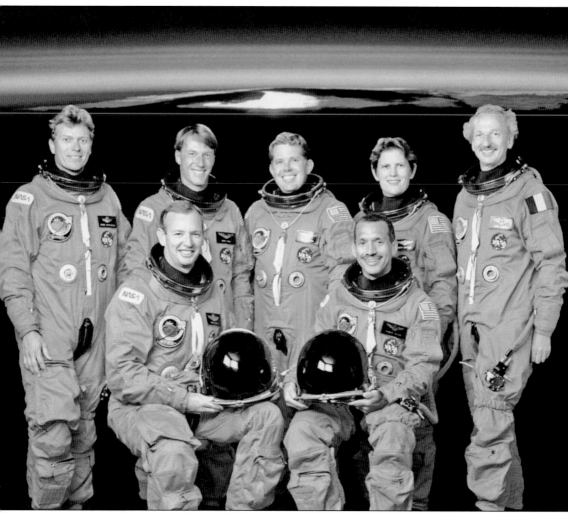

David Leetsma brought pride to the city of his birth when he was named an astronaut in 1980. After training in Virginia Beach, Virginia, he flew space missions in 1984, 1989, and 1992. He received numerous awards during his long career in flight. In this image, Leetsma is on the left in the first row. (Library of Congress.)

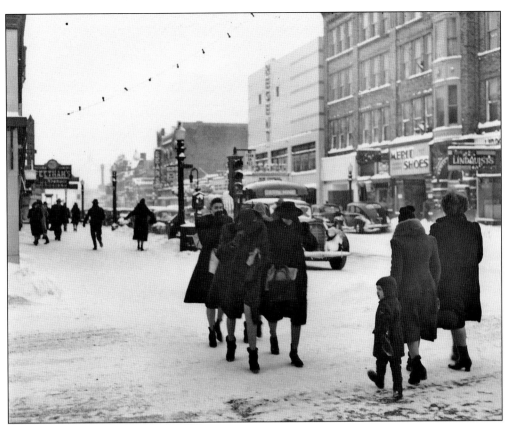

Residents may love it or hate it, but there is no escaping winter snow in Muskegon. All one can do is learn to live with it and carry on as usual, as these shoppers are forced to do.

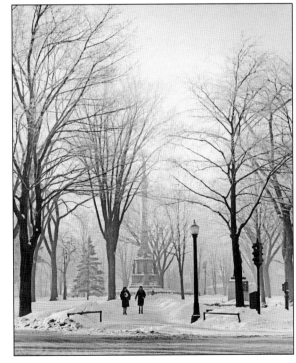

Even the most vehement of the haters can appreciate the beauty of freshly fallen snow in a setting like Hackley Park and maybe even enjoy a brisk walk in a winter wonderland.

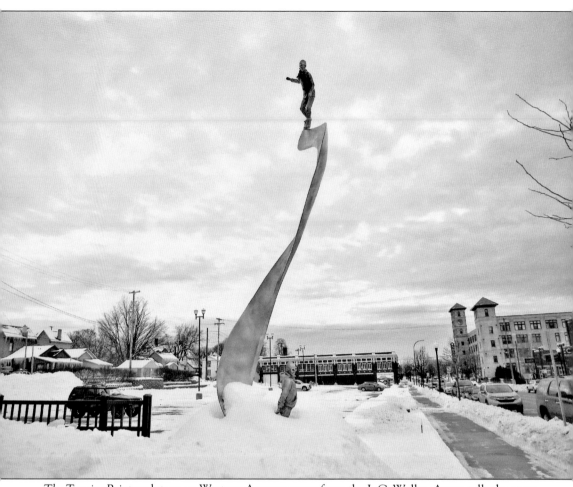

The Turning Point sculpture on Western Avenue across from the L.C. Walker Arena tells the story of "snurfing" (snow surfing), the sport of sliding downhill on two skis nailed together. Muskegon resident and snurf creator Sherman Poppen patented the predecessor of snowboarding, and it was manufactured by the Brunswick Corporation. The sculpture is of a snurfer at the top, with a modern-day snowboarder at the base. (Photograph by Norma Lewis.)

Following a near-death experience, Santa Claus, also known as John Studebaker, placed himself in charge of delivering holiday cheer to those who might otherwise be overlooked. Throughout the season, he fishes in his Santa suit, visits nursing homes and mentally and physically challenged children and young adults, and poses for free photographs with children unable to pay mall Santa prices. Lacking a sleigh, he travels in a Santamobile, tricked out with antlers. (Courtesy of John Studebaker.)

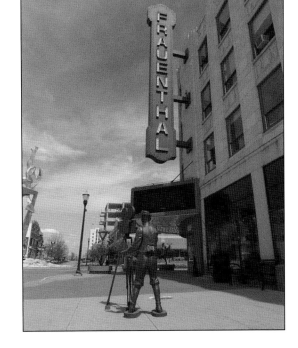

A sculpture of silent film star Buster Keaton is in front of the Frauenthal Theater. The Keatons, along with the rest of the Actors' Colony, regularly performed in the building when it was named the Michigan Theater. (Photograph by Norma Lewis.)

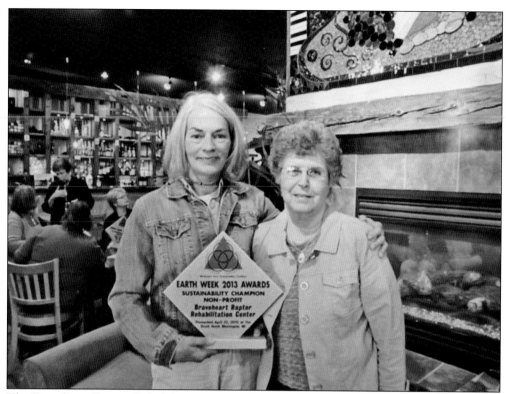

The Braveheart Raptor Rehabilitation Center at 6221 Sweeter Road in Twin Lake has been treating injured, sick, and abandoned birds of prey so they can be released back into the wild. In the image above, Susan Stamy, who owns the facility with her husband, Dave, is receiving an Earth Day 2013 award for being named the sustainability champion in the nonprofit category. Not all patients can be released. Bela, the peregrine falcon, shown below, is a resident goodwill ambassador and helps educate the public. (Courtesy of Susan Stamy.)

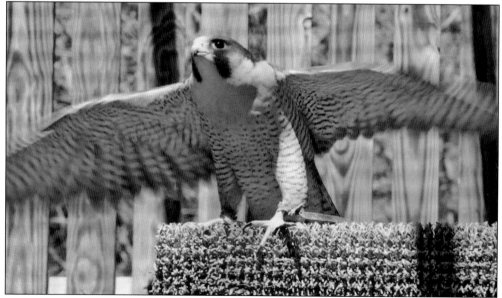

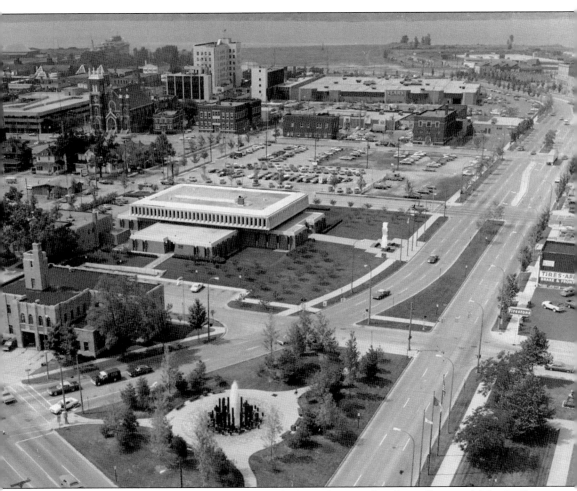

This aerial view of downtown Muskegon was taken in 1976 just after the mall opened. The mall, now gone, is shown in the center, and ships are visible in the background. Today, the city has restored the downtown area to showcase its rich history.

Discover Thousands of Local History Books Featuring Millions of Vintage Images

Arcadia Publishing, the leading local history publisher in the United States, is committed to making history accessible and meaningful through publishing books that celebrate and preserve the heritage of America's people and places.

Find more books like this at
www.arcadiapublishing.com

Search for your hometown history, your old stomping grounds, and even your favorite sports team.

Consistent with our mission to preserve history on a local level, this book was printed in South Carolina on American-made paper and manufactured entirely in the United States. Products carrying the accredited Forest Stewardship Council (FSC) label are printed on 100 percent FSC-certified paper.